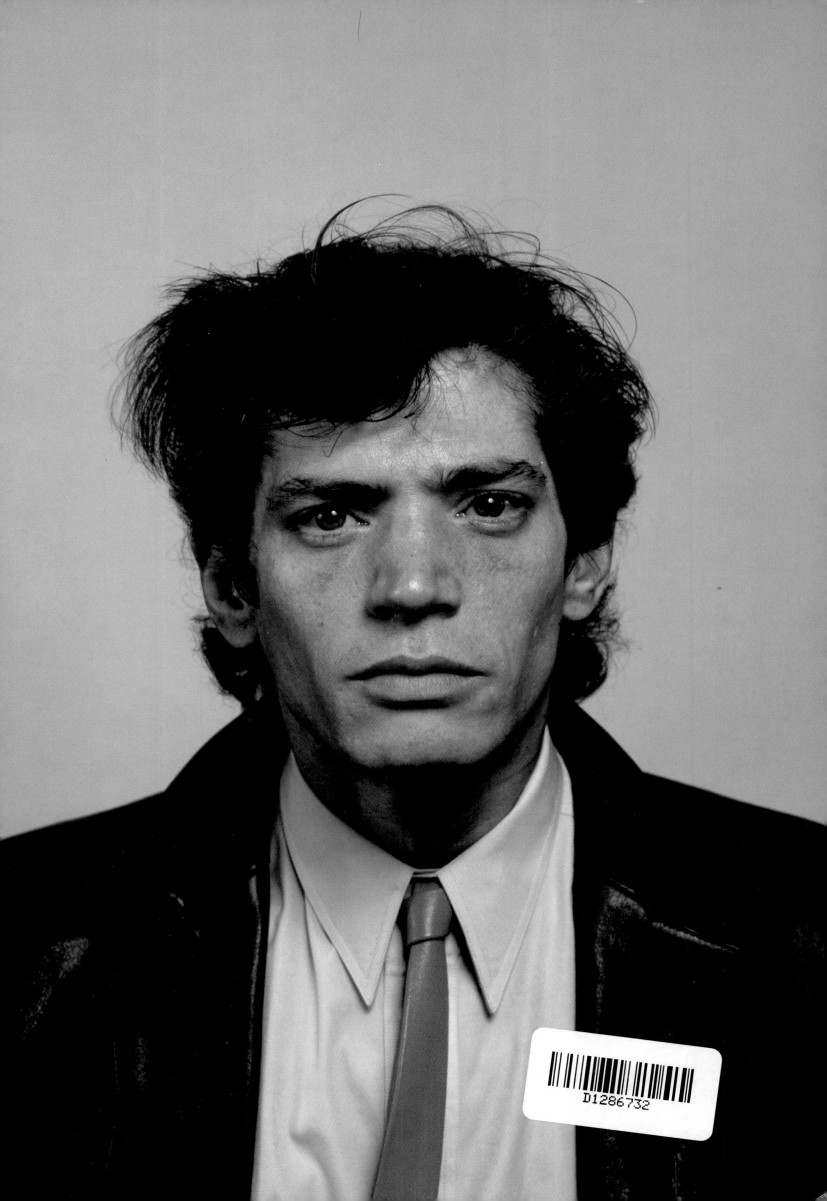

LIKENESS

LIKENESS

Portraits of Artists by Other Artists

Matthew Higgs

Kevin Killian

CCA Wattis Institute for Contemporary Arts, San Francisco

Independent Curators International, New York

This catalog is published in conjunction with the traveling exhibition *Likeness: Portraits of Artists by Other Artists*, organized by the CCA Wattis Institute for Contemporary Arts, San Francisco, and Independent Curators International (ICI), New York, and circulated by ICI.

Exhibition Curator: Matthew Higgs, CCA Wattis Institute
Exhibition on view at the Logan Galleries of the CCA Wattis Institute from February 27 to May 8, 2004.

ISBN 0-9725080-3-1
Library of Congress Control Number 2003116408

Publication Manager: Erin Lampe, California College of the Arts
Design: Eric Heiman, Volume Design
Print Coordination: Uwe Kraus, International Book Production
Printed in Italy.
The text of this volume is set in AG Book Stencil and Filosofia.

Generous sponsorship for *Likeness: Portraits of Artists by Other Artists* is provided by Tecoah and Thomas Bruce and by Joe and Beth Hurwich.

Significant support for the CCA Wattis Institute for Contemporary Arts has been provided by Phyllis C. Wattis and Judith P. and William R. Timken. Additional generous support has been provided by Grants for the Arts/San Francisco Hotel Tax Fund.

Independent Curators International has received generous support for the *Likeness* exhibition and publication from the ICI International Associates.

Cover: Heather Cantrell, *Singing Sirens (Mary Kelly)*, 2002
Orientation of image altered by kind permission of the artist.
P. 1: Neil Winokur, *Robert Mapplethorpe*, 1982
PP. 2–3: James Welling, *Jack Goldstein*, 1977
P. 72: Roy Arden, *Stan Douglas (#1)*, 1981–5

815

CONTENTS

FOREWORD &
ACKNOWLEDGMENTS

Likeness: Portraits of Artists by Other Artists is the first exhibition of its kind to bring into focus a recent history of artists' representations of other artists. While portraiture's long endurance as an artistic genre reflects our fascination with observing and studying the appearances of others, portraits offer only a highly subjective, often ambiguous record. As Matisse remarked, every portrait depicts not an individual so much as the relationship between artist and sitter. That relationship can be especially dynamic when the subject happens to be a fellow artist, and the resulting portrait—as evidenced by many works in this show—takes on a collaborative aspect. This is one of the reasons why artists' portraits have proven to be such fertile ground for reconsidering ideas around both partnership and authorship, and, ultimately, for reexamining the ways in which visual identity is negotiated in our post-Warhol era.

In presenting artworks made during the past three decades by a loose network of artists primarily active in Berlin, London, Los Angeles, and New York, *Likeness* surveys a variety of approaches to portraiture, examining how artists have questioned, and reimagined, what exactly constitutes a "portrait." At the same time, through works such as David Robbins's seminal *Talent*, 1986, which documented major players of the mid-1980s downtown New York and Los Angeles art scenes, the exhibition seeks to portray the social dynamics of certain recent contemporary art milieus. Reflecting on relationships between art and social life, as well as between practitioners engaged in the same highly competitive endeavor, *Likeness* reminds us that portraits, while ostensibly celebrating individuals, inevitably reveal telling information about the societies and cultures in which they are made.

This catalog and traveling exhibition have been made possible with the encouragement and dedication of a great many people. First and foremost, we extend our warmest thanks to CCA Wattis Institute curator Matthew Higgs for curating this exhibition with an approach that is at once insightful, imaginative, and highly informed. A special acknowledgment is also due to Higgs's coauthors in this catalog, Kevin Killian and David Robbins, each of whom has contributed thought-provoking essays that reflect their distinctive and original voices. Graphic designer Eric Heiman deserves considerable thanks as well for his crucial creative input into this publication.

On behalf of our boards of trustees, we would like to express our deepest thanks to Tecoah and Thomas Bruce and to Joe and Beth Hurwich for their generous support of this exhibition. In addition, we owe a significant debt of gratitude to all the participating artists, many of whom are also lenders. We are grateful, as well, to the following lenders, without whose generosity this exhibition would not have been possible: Julie Ault; Blum & Poe, Los Angeles; Janet Borden, Inc., New York; John Connelly Presents, New York; Alan Cristea Gallery, London; Elizabeth Dee Gallery, New York; Feature Inc., New York; MARC FOXX, Los Angeles; Fraenkel Gallery, San Francisco; Frith Street Gallery, London; Barbara Gladstone Gallery, New York; The Felix Gonzalez-Torres Foundation, New York; Marian Goodman Gallery,

New York; Michelle Grabner; Susan and Michael Hort; the estate of Peter Hujar; Adriane Iann and Christian Stolz; Ann Kneedler; Lisson Gallery, London; Robert Mapplethorpe Foundation, New York; Matthew Marks Gallery, New York; Elizabeth Murray; Pace Editions; Maureen Paley Interim Art, London; Javier Peres, peres projects, Los Angeles; Nancy and Joel Portnoy; Regen Projects, Los Angeles; Andrea Rosen Gallery, New York; Jim Shaw; Two Palms Press, New York; Dean Valentine and Amy Adelson; and those collectors who wish to remain anonymous.

For their help with arranging loans for the exhibition or otherwise providing assistance at key stages in its organization, thanks go to Lily Asalde-Brewster, Rosalie Benitez, Gavin Brown, Daniel Buchholz, Eileen and Michael Cohen, Clare Coombes, Victoria Cuthbert, Danielle DuClos, Cornelia Grassi, Lucy Greenwood, Philipp Haverkampf, Jasmin Jouhar, Lena Kiessler, Martin Klosterfelde, Joe Kraeutler, James Lavender, Hilary Lloyd, Rose Lord, Martin McGeown, Amber Noland, Jeffrey Peabody, Michelle Reyes, Bernadette Schwering, Mary Clare Stevens, David Trilling, Dawn Troy, Holly Walsh, and Andrew Wheatley.

The dedicated and energetic staffs of our institutions also deserve recognition for their efforts on behalf of this project. At the CCA Wattis Institute, thanks go to deputy director Leigh Markopoulos and administrative coordinator Deborah Sprzeuzkouski. We are also obliged to the entire Advancement staff at California College of the Arts for their help in producing this catalog, especially publications director Erin Lampe and copy editor Erica Olsen. At ICI, thanks go especially to Susan Hapgood, director of exhibitions; Annabelle Larner, registrar; and Amy Owen, exhibitions associate, who worked on every aspect of this exhibition. We also wish to acknowledge the work of Nika Elder, exhibitions assistant; Hedy Roma, director of development; and Sue Scott, executive assistant and press coordinator.

Finally, we extend warmest appreciation to our boards of trustees for their continuing support and commitment. They join us in expressing our gratitude to everyone who has helped in the realization of this exhibition, catalog, and tour.

JUDITH RICHARDS
Executive Director
Independent Curators International

RALPH RUGOFF
Director
CCA Wattis Institute for Contemporary Arts

TRUSTEES

ESSAYS

LIKENESS

MATTHEW HIGGS

MATTHEW HIGGS

LIKENESS

UNLIKE THE SELF-PORTRAIT

—WHICH, THROUGH ITS PECULIAR MIXTURE of narcissism, self-absorption, and self-conscious lack of objectivity, often takes the form of a kind of public self-analysis—portraits of other people tend to depict a more objective record of the social (and emotional) engagements and dialogues (whether real or imagined) between two or more individuals. Elsewhere in this publication the writer Kevin Killian identifies the portrait's embrace of this entanglement as a "social contract." Killian's "social contract" echoes art historian Richard Brilliant's assertion—in his important 1991 study *Portraiture*—that portraits embody a "representation of the structuring of human relationships."[1] Both Brilliant's and Killian's notions reverberate in a recent article about the work of the artist Friedrich Kunath, in which the British writer Dan Fox suggests that art "deals with our individual relationships to each other and to the world. No matter how deep the terms of discussion are couched in abstruse philosophies or socio-political histories, a lot boils down to economies of exchange: the fundamentals of how we see each other, how our bodies coexist with one another and the objects around us."[2] Fox could well have been thinking specifically about portraiture, where the degree of intimacy between author and subject—and the tensions such intimacy provokes—might be considered to be the true subject of such works.

Portraits of artists distinguish themselves from portraits more generally in that they are born of an encounter between individuals who share a similar defined social role. *Likeness: Portraits of Artists by Other Artists* seeks to consider a recent history of such encounters: artists' depictions of their fellow artist friends, peers, and idols. When an artist visually acknowledges a fellow artist, living or dead, there exists not only the recognition of another human being, but also the recognition of a peer. In this sense, artist portraits commemorate and concretize the intimate social dramas of the art world: the private (or privileged) interactions, relationships, and "economies of exchange" that typically exist beyond or outside public scrutiny.

The artist portrait represents—in ways that, for example, portraits of politicians or royalty cannot—a professional equilibrium, a dialogue in which the identities and status of both artist and subject are intertwined.

WRITING ABOUT THE JAPANESE ARTIST Hiroshi Sugimoto's photographs of wax museum displays (*Wax Museums*, 1976–) and his more recent series of portraits of individual waxwork figures (*Portraits*, 2000–), the curator Nancy Spector identifies how the wax museum "traffics in the verisimilitude of artificiality."[3] With all sense of historical and cultural hierarchy suspended through the wax museum's

commingling and indiscriminate juxtaposition of both real and fictional subjects, Spector proposes that the only "'truth' that matters in such situations is how 'real' each individual effigy appears."[4]

Amidst the anticipated Chamber of Horrors and innumerable effigies of movie stars to be found at San Francisco's Wax Museum at Fisherman's Wharf, the visitor will encounter an unexpected—given their general lack of visibility in society—display of wax sculptures of artists. If Spector is right in her assertion that the only criteria that really matters in the wax museum is the perceived "reality" of the wax version of its subject, then to what extent can a general audience "judge" the authority of a waxwork portrait of an artist such as James Abbott McNeill Whistler, about whose appearance they—and I include myself here—would probably know very little?

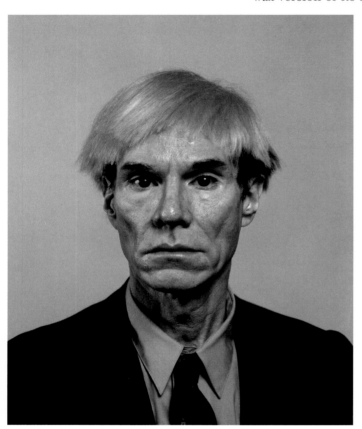

Neil Winokur *Andy Warhol* 1982

Unlike movie stars or historical figures such as Cleopatra, where there is a consensus as to these individuals' "actual" appearance, artists remain a largely obscure, or obscured, tribe. They are known, if at all, more for what they do (or did) than for who they actually are (or were). At the center of the San Francisco Wax Museum's random collection of artists—which includes an "Henri de Toulouse-Lautrec," a "Salvador Dali," and the afore-mentioned "Whistler"—is the unsettling ghostly presence of a silver-wigged "Andy Warhol" who appears uncannily lifelike, insomuch as the anonymous wax sculptor has somehow, and quite possibly inadvertently, captured the essence of Warhol's own self-determined spectral elusiveness.

Like all portraits—from Roman busts to those on bank notes—the San Francisco Wax Museum's effigies of artists are engaged in a dual process of both memorializing and idealizing their subjects. To be honest, I hadn't anticipated that there would be any portraits of artists at the wax museum. While the notion of the artist as celebrity is becoming increasingly commonplace, or at any rate the distance between artists and other popular figures is narrowing—ideas developed elsewhere in this publication by **David Robbins** in his consideration of his 1986 work *Talent*—the artist as suitable subject for the wax museum remains somewhat unconvincing. For the most part, the other waxworks at the San Francisco Wax Museum are widely known individuals or historical figures who have in some way caught the larger public's imagination. I'm not sure that any artist—even one as well-known as Andy Warhol—can hold his or her own against truly popular figures such as the Charlie Chaplins, Princess Dianas, and Pope John Paul IIs typically found in such situations. However, the presence of artists at the wax museum raises the question: to what extent is the general public interested in or able to acknowledge an artist's public image? From the visitors I witnessed scuttling past the artists display en route to the Presidential Library, one might reasonably conclude: not at all.

The fact that the general public remains largely indifferent to the idea of the artist within society has not hindered the microcosm that is the art world in its continuing fascination with the artist's personality, of which their visual likeness or public image constitutes an integral part. Warhol himself anticipated this fascination. Perhaps more than any other twentieth-century artist, Warhol sought to salvage the genre of portraiture from its somewhat privileged and elitist past. Warhol democratized portraiture, reimagining it as a more complex contemporary form that would reflect the shifting social hierarchies of postwar America. His blurring of

once firmly enforced social barriers—typically based around class, wealth, or social standing—saw drag queens, hustlers, speed freaks, musicians, and artists mixing freely and being portrayed alongside heiresses, movie stars, captains of industry, and minor royals. From the mid-1960s onward, Warhol made portraits of other artists, beginning with his filmed *Screen Test* portraits of artist visitors such as Marcel Duchamp and James Rosenquist to his East Forty-seventh Street studio, the Factory. (Subsequent artist subjects for Warhol's painted and silkscreened portraits include Joseph Beuys, David Hockney, Michael Heizer, Robert Mapplethorpe, and Peter Halley, among others.) In his portrayal of his artist peers—images that were often created in tandem with his commissioned portraits of socialites, sports stars, and minor European royals—Warhol seemed to be encouraging the notion that artists might increasingly be thought of as a kind of emergent parallel aristocracy, worthy of depiction and akin to the screen stars he had idolized as a child.

DRAWN FROM WORKS MADE OVER THE PAST THREE DECADES, *Likeness* considers artists' representations of other artists "after Warhol." Warhol's shadowy presence and influence permeate the exhibition. Warhol himself appears as the subject of **Neil Winokur's** blunt 1982 mug shot–like depiction that echoes the images of the at-large criminals that comprised Warhol's celebrated (and at the time scandalous) 1964 series of paintings, *Thirteen Most Wanted Men*. Warhol appears again, more obliquely, in **Richard Misrach's** *Playboy #38 (Andy Warhol)*, 1990: a photograph of a *Playboy* magazine that had been abandoned in the desert and used for target practice. Warhol's image as it appeared in a Vidal Sassoon advertisement, now bullet-ridden, evokes the violence of Valerie Solanas's 1968 attempt on his life.

Warhol was one of the few artists whose (cult) celebrity status was such that he was employed by advertising agencies to endorse commercial products throughout the 1970s and 1980s. Yet even if we agree with David Robbins's assertion that the contemporary art world might increasingly be thought of as a kind of "intellectual show business" and acknowledge the occasional high-profile artist's appearance in more recent advertising or fashion campaigns—Ed Ruscha modeling in Gap ads and Tracey Emin's endorsement of Bombay Sapphire gin come immediately to mind—the artist remains, even in an age of proliferating media opportunities, a relatively anonymous figure.

While artists' portraits of artists seek, in a modest way, to address this general lack of visibility, images of other creative individuals such as musicians and actors (and even writers) remain far more present in the public's imagination. Through their role as performers, musicians and actors trade on their audience's ability to identify with their unique persona: an identification assisted by the marketing and publicity departments of multinational entertainment conglomerates. Writers—with whom artists perhaps share more characteristics—frequently appear in highly mannered portraits on their book jackets, where they are invariably presented as serious individuals, worthy of the gravity that their words—and agents—demand. However, the identity of artists remains somewhat mysterious. The art world has no equivalent of the dust-jacket portrait, or the million-dollar budgets of Hollywood marketing departments. This general lack of visibility continues to perpetuate the mythology of the artist as outsider: an individual on the shadowy fringes of society. David Robbins's *Talent* was created partly as an attempt to counter this romanticized image of the artist. Robbins wanted "to create a picture of artists that was consistent with my own experience of the art world...the artists of my acquaintance were, and

remain, cheerful, funny, generous, and reasonable people. I resent the image of us as mad, romantic dreamers, hopelessly out of touch with reality."

GIVEN ROBBINS'S DESIRE TO "CREATE A PICTURE of artists that was consistent" with his own "experience of the art world," *Talent* does not represent a portrait of *the* mid-1980s New York and Los Angeles art world; rather, it portrays a *particular* aspect of the art world as Robbins encountered it. *Talent* privileges a specific milieu of Robbins's acquaintances, and as such, reveals something of the interconnectedness of a loosely aligned group of artists whose works collectively sought to interrogate the media landscapes of celebrity, marketing, and advertising. *Talent* is consistent with other artists' attempts to bear witness—through the portrayal of their artistic peers—to the "economies of exchange" between artists in specific social or cultural contexts. **Sigmar Polke's** seemingly drunken 1974 images of Gilbert & George record an early fraternal encounter between these artists that suggests a mutual investment in serious play. Similarly, **Roy Arden's** early 1980s portraits of his fellow Vancouver-based artist Stan Douglas, **Richard Prince's** 1985 portrait of Meyer Vaisman, and **Mike Kelley's** 1976 portrait of fellow artist and onetime Destroy All Monsters band member Jim Shaw were all created at an early and crucial developmental moment in each of these artists' careers. Each work crystallizes the nascent friendships between these artists, camaraderies whose true significance would only unfold—and be more widely acknowledged—later, as these artists gained international acclaim. (This form of mutual recognition has long been a subtext of **Chuck Close's** ongoing series of portraits of his artist peers and friends, exemplified in his recent silkscreened portrait of Lyle Ashton-Harris, *Lyle*, 2003.) **Paul Noble's** series, *Drawings of people who own books*, 1993–5, records those individuals, including a number of his artist friends, who each own early book works by Noble. Seen together, the twenty-plus drawings reveal an informal community of sorts: one determined and underscored by a common interest in Noble and, more specifically, ownership of his work.

Portraits such as those described above emphasize, reveal, and explore the social and intellectual dynamics of particular artistic circles. (Similarly, both **Wolfgang Tillmans's** and **Elizabeth Peyton's** myriad portraits of their artist friends and colleagues provide illuminating historical accounts of their idiosyncratic social interactions and movements within the art world.) In this respect, certain recent artist portraits subscribe to a dominant tendency within twentieth-century modernist avant-gardes: the self-reflexive desire to historically acknowledge the presence of the artist within key moments of cultural change. Photographers including Brassaï, Henri Cartier-Bresson, Harry Shunk, and Angelika Platten each created iconic documentary portrait accounts of the artists of their time. However, as documentary accounts, these images typically do not privilege the intensity of artist-to-artist relations as their "subject." (Man Ray's iconic portraits of his artist peers perhaps distinguish themselves in this respect, as do, say, Hans Namuth's near-collaborative images of Jackson Pollock.) In such documentary images the photographer often exists at a remove from his or her subject, with the portrait image ultimately existing as a form of reportage.

Eschewing such documentary accounts, **Likeness** instead considers those images that highlight (and seek to question) the intensity of the "social contracts" between two or more artists.

AA BRONSON'S *Felix Partz, June 5, 1994,* IS A billboard-scale photographic portrait taken a few hours after Partz's death. Partz, along with Bronson and Jorge Zontal, was a member of General Idea, a collaborative art practice that was, in his words, "an amalgam of life and art." Bronson's portrait represents a desire on his part to distance himself "from Felix, to take his death and return it to the public sphere, in which we had spent so much of our life together: I needed to place my relationship with Felix, as the living to the dead, on view to a public, to those who would bear witness to us. It was an act of someone very much alive."[5] This vital sense of someone who is "very much alive" could not be more apparent than in **Bruce LaBruce's** 2003 image of Bronson himself, who appears unrepentantly and cheerfully naked. Like Victorian photographs of the dead—which sought to both preserve and immortalize their (typically infant) subjects—Bronson's extraordinary and moving image of Partz functions as both a memento mori and an aide-mémoire, providing us with a complex visual account of an individual who appears as if suspended between life and death.

Mortality has inadvertently become in part the subject of **Tacita Dean's** lyrical 2002 film portrait of the Italian artist Mario Merz and **James Welling's** intimate 1977 portrayal of his friend, the artist Jack Goldstein. Both Merz and Goldstein died during the past year. Seen in this light, both Dean's and Welling's works have shifted from being tender portrayals of the living to poignant and melancholic reminders of the lives and contributions of those recently departed. Similarly, **Richard Hamilton's** 1998 portrait of his longtime friend and artistic sparring partner Dieter Roth—a print published in the year that Roth died—serves to celebrate the historical legacy of their collaborative mischief.

Bronson's frank portrayal of death reverberates in other images conditioned by the AIDS crisis, at its U.S. height in the 1980s. In **Nan Goldin's** and **Peter Hujar's** separate images of the late David Wojnarowicz, who died in 1992 at the age of thirty-seven, the portraits reveal something of the identity of an artist whose most iconic self-portrait showed the artist's face largely obscured beneath piles of dirt, as if in an open grave. Hujar's own death in 1987 at age fifty-three preceded that of Paul Thek (whose sympathetic portrait Hujar created in 1975) in 1988 at fifty-four.

Hujar's work, like that of Goldin, **Robert Mapplethorpe,** and **David Armstrong,** persistently acknowledges the larger presence of the social dynamics of their immediate circles. Seen together, their respective bodies of work operate, on one level, as a diary-like narrative based on the intertwined lives of their friends, neighbors, and colleagues. Armstrong's highly omannered 1980 portrait of Christopher Wool recasts the artist as if a matinee idol in a photographic concoction of Carl Van Vechten. This sense of the larger social dimension of portraiture is amplified in the late **Felix Gonzalez-Torres's** 1991 textual portrait of Julie Ault, a former member of the artists collective Group Material. Taking the form of a painted time line, which Ault is empowered to augment even after the artist's death, a portrait is conjured up through the inscribing of significant events, names, and dates that collide autobiographical moments in Ault's life with more general or universal concerns.

In **Sam Durant's** 1998 drawing derived from a photographic image of Robert Smithson, **Sean Landers's** 2003 series of drawings of twentieth-century European masters (an all-male cast that includes René Magritte, Francis Picabia, and Marcel Duchamp), **Jonathan Meese's** visionary 2001 painting of Balthus, and **Elizabeth Peyton's** 1997 watercolor image of David Hockney, we are not only presented with

portrait images of these artists, we are presented with portraits as a form of artistic homage. In each case, we are asked to consider an appropriated image onto which the artists have projected both a critical and fanlike reverence.

Matthew Antezzo's and **Dave Muller's** approaches to the inclusion (or appropriation) of existing portrait images are more conceptually and strategically complex. Antezzo's 2001 painting, *Nach-Bild*, shows the artist Frank Stella working on one of his signature "black" paintings of the late 1950s. Sourced from an exhibition catalog illustration—the caption that accompanied the image is retained in Antezzo's work—Antezzo's painting actually depicts a reproduction of a photograph of Stella that Stella and his friend Hollis Frampton contrived as a part of a larger sequence of images that were themselves modeled on an earlier series of documentary photographs of Picasso at work in his studio. Frampton and Stella's sly restaging of these images satirically placed Stella in the role of the heroic male artist toiling at his craft. The title of Dave Muller's *From Half-Tone Ad (Large)*, 1998/2003, similarly alludes to the source of its central image in an existing printed image of its subject, Chuck Close. Incorporating an image of one of Chuck Close's famous self-portraits, Muller's work not only reflects on the self-regarding nature of self-portraiture, but also, through its appropriation of Close's self-image, turns the work into both a "portrait" of Close and a commentary on the mechanics of publicity through which an artist's image and name become acknowledged.

Edgar Bryan's untitled 2001 portrait of his partner, the Los Angeles–based painter Laura Owens, casts Owens as a folksy bohemian idly strumming an acoustic guitar. Despite its somewhat self-conscious and slightly anachronistic nature, and its negation of formally identifying its subject, Bryan's portrayal of Owens exposes the tensions inherent in the depiction of a shared intimacy. In her acceptance of the role of subject, Owens becomes, like all willing portrait subjects, a witting collaborator in Bryan's representation. Similarly, **Richard Kern's** 1997–8 portraits of the artist Lucy McKenzie emerge from a mutual investigation into the classic (male) artist-(female) muse relationships, such as that which existed between Man Ray and Lee Miller. In their shared, participatory role within the construction of these images, both Kern and McKenzie foreground the degree of artifice that exists in the production of such images, where the traditional distance between subject and object is confused.

In her bold and somewhat glam 2002 portrait of Mary Kelly, **Heather Cantrell** colludes with Kelly in the construction of an image that seems to conflict with the typical mediated image of Kelly as an austere and critically rigorous individual. Here subject and artist contrive to re-image Kelly lounging by the pool, as if the subject of an Annie Leibovitz celebrity portrait for *Vanity Fair*. **Deborah Kass's** 1994 portraits of Cindy Sherman and Elizabeth Murray further amplify the portrait as masquerade. In her portrait of Sherman—an artist who, perhaps more than any other since Warhol, has sought to interrogate the potentiality of the portrait format—Sherman is recast as Liza Minnelli, as depicted in Andy Warhol's iconic 1978 portrait. Approximating to the last detail Warhol's 1970s portrait mannerisms, Kass confuses Sherman's already confused identity through her assimilation of both Warhol's method and his "look."

Anne Collier's ongoing series of *Untitled Aura Photographs*, 2003–, of her artist friends and peers seeks to question the authenticity of photographic portrait representations. Taken with a modified Polaroid camera in an Oakland "psychic store," the resultant portraits claim to make visible the subject's psychic energy, or aura. Reminiscent of Victorian "spirit" or "ghost" photography, Collier's images ask of their audience an investment in the notion that photography—and portraiture

more generally—can transcend its merely descriptive nature to somehow reveal the internal, psychological workings of its subjects.

CENTRAL TO OUR EXPERIENCE OF THESE WORKS IS the visceral engagement we have, as viewers, with images of other human beings: an experience made explicit in *This is Fiona*, 2000, **Julian Opie's** digitally animated portrait of the painter Fiona Rae, whose features acknowledge the viewer's regard. AA Bronson's expressed desire to place his relationship with Felix Partz "on view to a public" underscores the social intention and nature of artists' portraits of other artists. Such a desire is, according to Richard Brilliant, a response "to the natural human tendency to think about oneself, of oneself in relation to others, and of others in apparent relation to themselves and to others."[6] This need "to put a face on the world," in Brilliant's view, "catches the essence of ordinary behavior in the social context; to do the same in a work of art catches the essence of the human relationship and consolidates it in the portrait through the creation of a visible identity sign by which someone can be known, possibly for ever."[7]

> Existing at the interface between art and social life, artists' representations of other artists make apparent—and permanent—the otherwise fragile "economies of exchange" between artists.

NOTES

[1] *Richard Brilliant,* Portraiture *(London: Reaktion Books Ltd., 1991), 9.*

[2] *Dan Fox, "A Song in My Heart,"* Frieze *79 (November–December 2003).*

[3] *Nancy Spector, "Reinventing Realism," in* Sugimoto: Portraits *(New York: Guggenheim Museum, 2000), 18.*

[4] *Brilliant,* Portraiture, *9.*

[5] *AA Bronson, interview by Matthias Herrmann, in* AA Bronson/Felix, *June 5th, 1994, exhibition catalog (Birmingham, England: Ikon Gallery, and Toronto: Art Metropole, 2003).*

[6] *Brilliant,* Portraiture, *14.*

[7] *Ibid.*

ON TALENT
DAVID ROBBINS

FROM WATTEAU'S FÊTES GALANTES

TO THE IMPRESSIONISTS' DEPICTIONS OF DANCE HALL PERFORMERS, from Picasso's harlequins to Warhol's Marilyns and Cindy Sherman's film stills, visual artists have long created representations of the entertainers and entertainments that delight, distract, and scandalize society. However, artists have generally kept the world of entertainment at arm's length, using its forms and content while preserving art's aura of superiority over the less refined character of mass culture.

I wanted to challenge—and perhaps destabilize—this tradition with *Talent*, an editioned work that I created in 1986. Composed of eighteen black-and-white headshot portraits of artists who were then based in New York and Los Angeles, *Talent* offered up an image of the artist for our times. When the work was first exhibited at Metro Pictures in New York, Roberta Smith, writing in the *New York Times*, deemed it "too au courant for its own good." And yet, *Talent* struck a chord. It has since entered nearly one hundred public and private collections.

REWIND

I had multiple aims in making *Talent*.

I wanted to depict artists from the perspective of the larger business culture.

I wanted to depict artists in a way that was consistent with my own experience of the art world. By and large, the artists of my acquaintance were, and remain, cheerful, funny, generous, and reasonable people. I resented the image of them—of us—as mad, romantic dreamers hopelessly out of touch with reality, and I sought to make a different image, to suggest that these were good people and that art was a reasonable pursuit.

I was also interested in making portraiture. I'd always liked the clean black-and-white look of Man Ray's portraits of artists, but I wanted to inject more contemporary content into the genre.

Contemporary artists operate in two worlds: on the one hand, they're involved with ambitious aesthetic, intellectual, political, and moral stances; on the other hand, they're public figures who function as entertainers. Contemporary art is a kind of intellectual show business.

The photographic convention of the talent headshot satisfied these requirements, integrating them seamlessly.

It was imperative that the pictures taken be actual headshots, not just look like them; they were not to be mere representation but *fact*, embodied. To more completely avoid the dreaded taint of parody, I hired a professional entertainment photographer, James Kriegsmann Jr. At the time, the Kriegsmann studio had been in operation in the same building near Times Square since the 1940s; I passed it daily on the way to and from my apartment in Hell's Kitchen. Kriegsmann took all the pictures for my project, thirty-six shots of each artist. I functioned as the artists' agent, booking the sessions, seeing to it that the subjects arrived at the studio at their appointed hour, and paying the bill.

Alan Belcher

Jenny Holzer

Michael Byron

Joel Otterson

Clegg and Guttmann

Steven Parrino

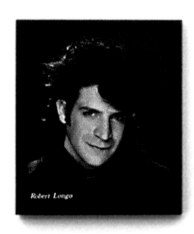

Robert Longo

Robin Winglinski

Ashley Bickerton

Larry Johnson

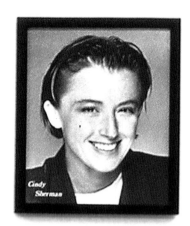

Cindy Sherman

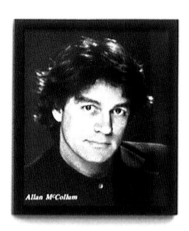

Allan McCollum

Thomas Lawson

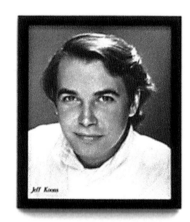

Jeff Koons

Gretchen Bender

Peter Nagy

Jennifer Bolande

David Robbins

David Robbins *Talent 1986*

I started out wanting to picture artists who acknowledged the role of entertainment in their own work: Robert Longo, Cindy Sherman, Jeff Koons. But then I realized that, to the business world, an artist's subject doesn't really matter. The business world views all artists in the same way, without regard for the subtle distinctions of media or meaning. My selection process then widened to include friends and acquaintances. *Talent* wasn't a portrait of *the* art world, it was a portrait of *my* art world.

I told the artists that I wanted to make a respectful portrait of them. I relied on their trust. That's an important part of *Talent*—that the artists trusted me enough to subject themselves to being interpreted through this work.

I selected the final picture of each artist. Consistent with the formal look of headshots, which present people as amenable and easy to work with, the mood of each photograph is upbeat and optimistic. These are images of artists who hope to get more work, who are looking forward to the future, who *have* futures. "Hope to be working with you soon!"

Once the photographs were printed, I chose to title the work with the single word "talent."

Generally talent is perceived as a positive trait. Yet some people have considered Talent a cynical work. Not long ago, a friend reported overhearing a viewer comment, "I think it's some sort of joke." But to me it's a sincere expression of optimism, hope, and good things to come.

THE IMAGE OF THE ARTIST

Most of our images of artists come from photographs. Old man Picasso, the superfertile genius, fiercely studying a painting in progress while standing before it in his underwear. Scary Warhol, the black-leather-clad equal of the camera's lens, supremely cool and unflappable. O'Keeffe, the earth mother. In each case it's the camera that enabled these artists to concoct and promote a mythic self-image. In order for that image to reach the masses, each artist engaged in collusion, not just with a photographer but also with a mass publication and distribution system. As professional image-creators, artists are unusually attuned to the mechanics of legend building.

Talent infused a frank acknowledgment of collusion directly into the portrait itself. Having identified a specific picturing system, the entertainer's headshot, which didn't hide its aims (couldn't, in fact: headshots have their economic life—the way they function in the economy *as photographs*—built right in), I used that picturing system to present visual artists. The result was an emblem, one with specific qualities borrowed from entertainment culture, that denied visual artists their accustomed distance from—and superiority over—that culture.

A TRIANGULATION

The headshot is an artifact designed to serve a communication system that is entirely independent of the concerns of fine art. It doesn't admit much sentiment. It replaces the image of the artist as romantic actor with another, more pragmatic image. Instead of transcendence, we get something earthbound. In the headshot, the image of the artist shifts away from the fragility and misery of a van Gogh, toward something shinier, more confident, and possibly less refined. There's also a shift away from social marginalization and toward social participation.

Talent uses a picturing system that remains separate from art, that does not seek art's blessing, and that has a different set of aspirations. Its framing of art runs counter to the art world's celebration of itself as a world apart. It expresses skepticism toward the art world's certitude that art is and ought to be the terminus point

of the imagination, the pinnacle. If *Talent* is a critique of anything, it's a critique of this certitude.

That something might stand outside art and report on it, comment on it, editorialize about it in *an iconic language of its own*—this was, and apparently still is, disorienting. The reason, I submit, is that it instantiates a complication of the modernist dialogue between life and art. *Talent* suggests that the old binary model has been superseded by a triangulated model whose points are life, art, and entertainment—a competing communication system as madly self-sustaining, self-referential, and self-celebratory as art. "Showbiz" adds another category that's neither art nor life.

MAYBE THE NEW, STUPID AMERICA ISN'T REALLY THAT STUPID

The insight that artists are a species of entertainer isn't especially profound. What made *Talent* stand out was the fact that the work conveying the news was aggressively contemporary in its form and unapologetic in its attitude.

Talent was made by an affluent suburban American who'd watched a lot of television, listened to a great deal of pop music, and hadn't had much exposure to or feel for classical culture. Civilization's self-appointed defenders like to assert that a pop-defined background will never yield imaginations as substantive as those formed under more refined conditions. They may be right. The jury is still out. Yet for any whose formative years coincided with the pop era, the assertion has about it a certain arrogance.

In reducing or erasing the gap between artist and entertainer, *Talent* cheerfully represents another step in American culture's gradual movement away from its European inheritance. To Americans, that earlier cultural model, with its hierarchical ranking of one pleasure over another, has come increasingly to seem at odds with this country's homegrown culture. Predicated on the concept that beer and champagne may be compared as *symbols*, but that the *pleasures* these produce in two different individuals may *not* be ranked, American culture is adamantly horizontal.

A work such as *Talent* merely acknowledges our understanding that no one part of communication culture, no one form of expression, has a lock on truth. A viewer of *The Sopranos* may derive pleasures from it which, while different in kind, are just as real and just as satisfying as the pleasures derived by a viewer of the paintings of Gerhard Richter. Television communicates something that paintings can't, and vice versa. To those of us who have been raised in a democracy of pleasures, any hierarchical ranking that places Richter above *The Sopranos* just isn't as convincing as it once was. For better or worse, much of the world is evolving in this direction. And the United States started this particular ball rolling.

Creating a work that acknowledges this social fact didn't make me feel cynical. On the contrary, I felt sincere and honest. As far as I was concerned, it was the classical hierarchy—artist above, entertainer below—that felt untrue and inauthentic. We needed another paradigm.

THE SUBURBANIZATION OF THE IMAGINATION

Every generation of artists configures culture to match its own experience. The conditions of our upbringing imprint us, and when we come to maturity we return the favor, imprinting our sensibilities upon the culture and bending it to our wills. The organism receives stimuli; the organism eventually responds.

Let me identify two factors that have distinguished our experience of landscape—our experiential landscape—from that of preceding generations.

First, much of our experiential landscape has been of a synthetic, fabricated

nature. Actually, for us the synthetic approximates the natural; if nature had money it'd be TV. Films, TV, radio, magazines, advertising, computers—media is now indivisible from our experience. Once upon a time, movies, TV, radio, etc., merely *commented upon or reflected* our experience. Now, however, our exposure to them is so constant—partly because their role in our economy is so integral—that, rather than merely commenting upon or reflecting our experience, these communication forms *comprise* much of our experience. (My imagination was formed during this latter phase. So, perhaps, was your own.)

The second, more invisible but just as consequential experience of landscape that has imprinted on us our notions of truth and falsity is also, in a way, synthetic. Here, I intend the term to mean not "plastic," but rather, a "synthesis," a blend. This synthesis is manifested in an actual, physical landscape, the suburb—neither city nor country but instead an amalgam of the two: trees 'n' traffic. I and most young Americans grew up in such a landscape. The mass, middle-class suburbs, like the synthetic landscape of pop culture, are a fairly recent phenomenon. Until World War II, suburbs were primarily for the well-to-do. Most people lived in cities, small towns, or rural areas. The idea that vast numbers of people would live in neither city nor country is, in the United States, not much more than fifty years old. When you consider that it takes twenty or so years for a generation to mature and make an impact upon the culture, it becomes clear that imaginations informed by suburban experience are a recent addition to our cultural life. Since an enormous slice of the demographic pie was raised in the suburbs, the imagination conditioned by the suburban landscape is starting to have a significant impact on the direction of our culture.

What is truth to a mind so conditioned? The planned naturalism, the man-aged, neurotic landscape, the awkward "in-between" condition of the suburbs—this feels "right" to many of us. States that reconcile two states, things that are two things at once, that are resolutely, calmly, insouciantly impure—to us, these places feel like home. We are drawn to them.

And we also create them. As the suburb blurs or negates the distinction between city and country, imaginations imprinted with suburban experience want to blur, ignore, deny, or transcend distinctions between other categories. To such imaginations, the classical distinction between contexts—between, say, the context of art and the context of entertainment—feels less than accurate, because its purity fails to correspond with the hybrid landscape we have experienced. For such imagi-nations, neither the experience of art nor the experience of entertainment seems by itself sufficiently complex or sufficiently true to their experience, and therefore neither context is sufficiently satisfying. They can't look at art anymore without awareness of the dominant presence of entertainment culture, and they can't look at the powerful and pervasive entertainment culture without aching to refine it and to demand more from it than it is usually willing to give us.

In place of the classical either/or—city or country—the suburbanized imagina-tion prefers the creation of cultural product—activity, gesture, and artifact—that is both/and, or that is "in between." It looks for, demands, and creates hybrids, blends, and mongrels. Any one context by itself isn't rich enough. This kind of mind seeks satisfaction in contextual genetics, a gene splice. We are, all of us, post-collage. (Adobe Photoshop is the right tool for our time.) By identifying and framing the overlap between artist and entertainer, *Talent* indicates a position outside both models. *Talent* is frankly and unashamedly suburban.

If it only represented the way our world worked, *Talent* would be a work of journalism, not a work of art. But its equating of artist and entertainer isn't entirely true. The two roles are *not* exactly congruent—yet. *Talent* thus represents both a dry-eyed social reality and a fantasy. On a personal level, it was wishful, an expression of its author's desire to participate in showbiz. In a less personal sense, though, *Talent* was prophetic. The hybridized role that it imagined is indeed coming to fruition. A convergence of the roles of "artist" and "entertainer," suggested initially by the career of Andy Warhol and accelerating in his wake, is progressively blurring some of the essential particulars—media, venue, distribution systems—that previously separated the two fields.

Are artists appearing with regularity on David Letterman? Is there a TV show called Art World Tonight? Is art fame just as big and just as consequential as mass media fame? No. But the future is never merely a projection of present conditions.

In a tentative, trial-and-error way—the slow, experimental way we ought to have anticipated—the change *is* happening. The process is evolutionary rather than revolutionary. The painter Julian Schnabel makes films for mainstream theatrical release, and the lead in *Before Night Falls*, his most recent film, is nominated for an Academy Award. The artist Alex Bag makes videos that play like art world sketch comedy. "Showman" artists such as Damien Hirst or Maurizio Catellan make highly public, highly accessible work. Matthew Barney does whatever the heck he does, and three hundred thousand people trek to the Guggenheim to try to figure it out. Your parents may have heard of Cindy Sherman.

But that's mentioning only the stars. The more profound and lasting evolution is structural. It's taking place among countless young artists whose names we don't know yet. Thanks to the computer, kids are evolving away from the version of culture that maintained those tired divisions between contexts. With the computer, the active imagination can now create a wide variety of communication products, efficiently. On my laptop I'm developing texts for magazines, a book, several screenplays, Photoshop pieces for galleries and museums, videos that think of themselves as television, and audio pieces that think of themselves as, well, amusing trifles. Using this single, compact tool, an individual may produce in the "entertainment" formats of the mainstream mass media—the TV set, movie theater, boombox, video game, and website—and, equally authentically, in formats appropriate to gallery and museum. In short, we are becoming contextually ambidextrous. The change in the artist's self-perception that is emblematized in *Talent* precedes the computer, but it's the computer that is accelerating the exploration of that change, naturalizing it, allowing for its articulation, and reinforcing it.

To the contextually ambidextrous, the pertinent question is no longer "what infinite variety of materials, strategies, concerns might we include in the context of art?" It isn't "what might we map onto the coordinates of art?" These were the questions of modernism. The more contemporary question—tomorrow's question—is "who are we when we pursue a larger field of production, *some of which* is art?"

DAVID ROBBINS is an artist and writer currently living in Milwaukee. He has enjoyed more than thirty one-person exhibitions of his artwork in the United States and Europe, and his essays have appeared in numerous publications, including *Artforum* and *Parkett*. In 2003, his ongoing project, *The Ice Cream Social*, was the winner of the Sundance Channel's first TV Lab competition.

TWO-WAY STREET

KEVIN KILLIAN

KEVIN KILLIAN

STREET

TWO-WAY

I'D GIVE THE WORLD TO HAVE

BEEN PHOTOGRAPHED BY CARL VAN VECHTEN, but I was only a little boy when he died and hadn't done anything yet to distinguish myself as a homosexual or a modernist. Also, I was white. Van Vechten (1880–1964) was a 1920s novelist with an essentialist faith in the vitality, creativity, and sexual superiority of black America (to promote the Harlem Renaissance he published the scandalous *Nigger Heaven* in 1926). At the age of fifty he foreswore fiction and took up photography instead. Maybe if I'd been a super-talented young black boy in the very early '60s—like Stevie Wonder—I'd have had a shot. Despite a late start Van Vechten managed to shoot most of midcentury modernism—Faulkner, Calder, Chagall, De Chirico, Fini, Gershwin, Graham, Kahlo, Hartley, Matisse, Miller, O'Keeffe, O'Neill, Man Ray, Robeson, Stieglitz. He'd put up crappy little "artsy" tableaux out of whatever was lying around the apartment and posed his subjects ultratheatrically—a Jack Smith before there was a Jack Smith, with none of Smith's irony. Though this list doesn't reflect the balance, the majority of his sitters were either gay, lesbian, or talismanic emblems of the Carol Channing sort. Thus for the gay viewer an instant intimacy is brokered—"soldered" might be a better verb, for the photos are hot. The novelist Coleman Dowell comes alive in an explosion of longing. Barbados-born George Lamming, author of *In the Castle of My Skin*, poses in front of a rustic Connecticut fireplace, stones poking out of mortar as if in agony—a

You didn't have to be gay to be photographed by Van Vechten, but you have to be gay to know who all of his subjects are.

postcolonialist vision of black dashed across white. You know how "amateur" porn is now the hot new thing? That's the feeling you get leafing through Van Vechten's photographs—can they get any more garish and cheap? *And the answer's always yes.* He's the Neil Diamond to George Platt Lynes's Mozart. You wonder, what was he thinking? And of his subjects, you wonder, were they in on the joke of history?

Portraiture's a double-edged sword, as I first realized when I was ten or eleven, reading Agatha Christie's *Five Little Pigs*, 1943. Who killed Amyas Crale, the Augustus John–like painter with Rabelaisian appetites? Belgian supersleuth Hercule Poirot's baffled until he examines more closely the painting on which Crale had been working when he died—the portrait of his mistress, Elsa Greer, perched on a Cornish battlement, insolently glorious in a blue and yellow Aertex shirt. Eventually Poirot identifies the expression on her face as that of a killer, the killer who laughs in triumph as her lover dies—as he's painting her—from the poison she's laced his beer with. She gloats as she's posing, as Amyas Crale dies, his last strokes a mess of heroic gesturalism. He's dead, but her portrait lives on. Turning the last pages of *Five Little Pigs*, I whistled through the gap in my front teeth, marveling at Elsa's barbaric courage! Thus I learned of portraiture's cruelty, the threat of the subject position. I never fell for any of that Amish stuff about "don't let them take your picture, it will steal your soul"—it's the other way round, surely. Christie, who as a young woman

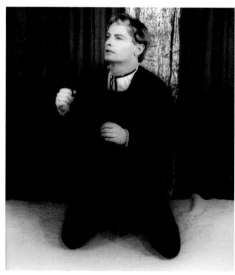

Carl Van Vechten
Donald Madden as Hamlet
1961
Black-and-white photograph
10" x 8"
Collection of the author

had faked amnesia to help dissolve a tormented marriage, wrote a pseudonymous roman à clef about her experience and called it *Unfinished Portrait*, 1934—clearly the tangled subject-object relations of portraiture intrigued her, infected me. In the portrait is the pictured human being the subject or object? When you consider the famous unfinished portraits—Gilbert Stuart's 1796 portrait of George Washington (the Athenaeum portrait), his shoulders bubbling into masses of white canvas; Jacques-Louis David's 1798 unfinished portrait of Napoleon at the Louvre, body by Etch-a-Sketch; Francis Bacon's 1992 pinkish Brussels sprout of a self-portrait—it's hard not to think that portraiture involves some kind of preemptive rehearsal for death. I say, when you jump in front of a painter or photographer, it's either him or you. Such positionality isn't big enough for both of us. The portraitist while ostensibly immortalizing his subject is having his cake and eating it too, while Elsa Greer—whom I take as emblematic of the portrayed fighting back—sits on the wall, serene. To the eye what difference between life and death?

Agatha Christie is a writer driven by modernism and its dramatic tropes. (I think I like her like that.) Her chaste *Autobiography*, 1977, largely an account of her childhood and youth, documents her exposure to Whistler, Sargent, the Arts Club, all the way to the Ballet Russes, the multimedia triumphs of which presaged the Debordian "society of the spectacle."[1] It took me a while to suss out that *Five Little Pigs*, with its death-dealing portrait, is a partial (and feminist?) rewrite of Oscar Wilde's *The Picture of Dorian Gray*, 1890, with Elsa as Dorian and Amyas Crale a composite of the poisonous Lord Henry Wotton and the lovesick painter Basil Hallward. Wilde's novel tells the story of a gay painter whose portrait of an innocuous Adonis wreaks a magical spell; while the face in the painting ages, Adonis afterwards retains his glorious youth. Unfortunately youth's preservation comes accompanied by a growing moral decrescence, manifested only on the canvas, which Dorian stows away behind a curtain, while killing everyone who guesses its secret, including the painter. Basil's sin is not, perhaps, in painting the maniacal portrait, but in his failure to acknowledge the implications of its creation.[2] He blames everything else, even nature and the weather:

> "The thing is impossible. The room is damp. Mildew has got into the canvas. The paints I used had some wretched mineral poison in them. I tell you the thing is impossible [. . .] You told me you had destroyed it."
> "I was wrong. It has destroyed me."
> "I don't believe it is my picture."
> "Can't you see your ideal in it?" said Dorian, bitterly.

Whatever else it is, the portrait, like any other work of art, is a social contract between human beings, narrowed in this case to two—and thus is often said to return the humanism that modernism systematically removed from art. But what if it's precisely the opposite? Anne Collier's aura Polaroids of some artists she admires—*or does she merely, under a cloak of admiration, detect beforehand that the machinery of portrait-making will make them good subjects?*—show this process in full bloom. In my Cold War youth, we were told that the Stalinist scientists Semyon and Valentina Kirlian had developed a camera that would take pictures of one's soul. Their surname

The fantasy of the living portrait, whose surfaces shift irrevocably toward decay, has crept into our feelings about art, altered their structure. The contemporary portrait emanates anxiety, its aura a menace of malevolent will.

was so close to mine that I decided they must be some distant Russian cousins with a similar interest in finding out what's under one's neighbor's skin. (The nuns also told us that Stalin and Beria had invented Bigfoot to help them take away Tibet from whomever it belonged to earlier.) Kirlian or "aura photography" gives back to the model what Wilde denied, agency. Bands of shimmering, yet ultimately unreadable color whip from the model's head and shoulders, while the photographer falls back, mouth agape, stuttering disclaimer. I grew up wanting to be portrayed, yearning for that power, for my aura to be seen and registered and feared.

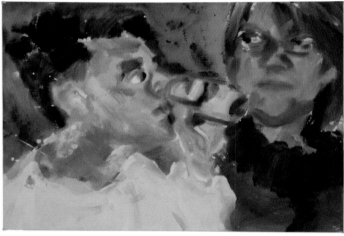

Dietmar Lutz

For Dodie and for Kevin
2001
Acrylic on canvas
20" x 31"
Collection of the author
© Dietmar Lutz

In the 1950s the poet James Schuyler characterized contemporary relations of writers to artists as those of humble tugboats guiding huge proud liners into harbor.[3] Under the barter system I posed in 2001 for the German painter Dietmar Lutz: he would paint my picture, and I would write a story about him. Could anything have been more ludicrous? Could any prospect have filled me with more dread or terror? He rolled paint on his big wide brush, a creamy mauve. I watched the paint drip from the brush into the open pan. It made a satisfying sound. Slap, slap, the brush dripping with mauve oil traversed the shapeless canvas. I saw a tiny mauve trickle slither down Dietmar's right hand toward his wrist. I had used his ignorance of U.S. ways to convince him that I was a famous American writer. It now seemed a kind of cultural imperialism. I kept telling myself, "He's the tourist, not you. He's the one invading your country." But I merely stared, holding a can of Diet Pepsi to my lips, mute with the dread of him who knows he shall kill the man who paints him. For he who glimpses the head of Medusa must turn to stone. Warhol: "OK, Marcel Duchamp, you stand over there, and just watch the birdie. Can I get you anything from the deli?" Duchamp: *"Et où allez-vous vous volatiser?"* Warhol: "I don't like to watch these things." Duchamp: *"La vérité, c'est que vous n'osez pas. Et après vous ne regarderez pas les films développés, car vous n'osez pas."* The model as Eros, the artist as Psyche—oil from the inquisitive lamp burns Eros' cheek, his angry beauty drives Psyche to exile. Dietmar straightened up, his lips pursed, watching my face emerge from the paint. At that moment I felt almost a bemused tenderness toward him, the mocking salute Dorian Gray throws to Basil Hallward. "There is something fatal about a portrait," says Dorian. "It has a life of its own."

The present exhibition, *Likeness*, oscillates between poles of gothic vision. In AA Bronson's 1994 portrait of Felix Partz, captured mere hours after death, breath still hovers around his form, around the gypsy bedclothes. Partz's bed hangings are so colorful it's as if color itself is a defiance against AIDS. The remote control to his left is an amulet to ward off inevitable giving way of control. It's an image that echoes David Wojnarowicz's unfinished film *Death of Peter Hujar* and indeed, Hujar's own iconic shot of Candy Darling, the ethereal Warhol superstar, dying in a cold hospital bed. The old saw about the eyes that follow one across the room, the famous trope of gothic writing and Hammer horror, is made manifest here in huge, shuddery displacement. Eyes that will not close (from facial wasting in literal terms; from refusal to surrender in metaphor).

The horror continues with *Balthys I*, 2001, Jonathan Meese's memorial to the late Count Balthasar Klossowski de Rola, or Balthus. The creepiest painter of the twentieth century gets a full-dress *Fangoria* makeover that incorporates aspects of horror from a wide temporal and geographic spectrum—from the peripatetic expressionist Mabuse of Fritz Lang's UFA films of the 1920s to the kink of Dr. Cyclops, produced in Hollywood by Universal Studios in 1940. Look at that ray coming out

of Balthus's one good eye. Like the Cyclops, his one eye is a hundred times more powerful than anybody else's two eyes. And that chalky uber-Aryan complexion, ugh. I know about Balthus only what I used to read in *Vanity Fair*, the magazine for whom he emblematized high art, as the delectable sum of culture plus trash. He would imply to reporters that his father was the poet Rainer Maria Rilke, who died of picking a rose. Look at that rose in his hand, which he seems to be searching for yet missing with his powerful vision. The eeriness of the painting compels us to believe that, dead or not, alive or not, Balthus ordered this portrait to be made. In choosing as his fabricator the boisterous Jonathan Meese, Balthus displays those qualities of pragmatism and masochism that kept Mabuse alive into the age of Count Chocula.

More subdued, the well-scrubbed artists of Sean Landers's fanboy imagination sport bankers' lapels and the dignified cross-hatching courtroom artists use to lend depth to felons. Heads meet up with shoulders sort of unexpectedly. Beckmann's shoulders are huge wings, his head a little insect face. Picabia's head is about to blow off his shoulders like a tumbleweed on a mesa. Braque, De Chirico, and Ernst all have George Plimpton hair—that luxurious professory hair that enraptures coeds and just looks better the whiter it gets. All the artists share a stiffness and stylization of expression that's half Russian formalism, half postage-stamp art. Sean Landers's subjects can give as good as they get. No matter how he caricatures them they will remain greater artists than he. Therefore we read his 2003 suite of drawings as an exercise in masochism and futility (as we do all efforts at tribute and homage). Out of the juncture, the syncope, between our knowledge of the weirdness of their art and Landers's gestures toward bourgeois professionalism, rises up both laughter and a kind of terror. These portraits disturb with their resemblance to the grim linotype portraits, in severe black frames, that glare from the walls of SS offices in U.S. anti-Nazi films of the 1940s. State-sanctioned art always smells musty, horrific. John Singer Sargent, asked by Max Beerbohm his opinion of portraiture, sighed and replied, "A portrait is a painting where there is always something not quite right about the mouth."

NOTES

[1] *Christie, who herself trained as a singer, bestrews her novels with Diaghilev-like impresarios, dying ballerinas, cruel painters, visionary sculptors. Giant's Bread, 1930, tells the story of a radical composer, Vernon Deyre, whose posthumously produced opera eschews conventional orchestration in favor of newly invented instruments called "the glass" (instead of "the woodwinds"), etc.*

[2] *Incidentally, Basil turns Dorian homosexual by painting him, the same favor Van Vechten may be said to confer on his subjects.*

[3] *One could write a companion essay on portraiture as a class-based form, tracing the shift of oppositional relations between subject and painter from (say) the Renaissance patronage system, through the modernist era in which the artisan class assumes enough cultural capital to feel itself superior to that which is painted (with the helpful assistance of Wildean modernism, which insists that the subject becomes object), through to such japes as the Dinner Party of Judy Chicago, an act of Althusserian interpellation: "I name you, you are one of us." And through to the contemporary period in which a Lucien Freud can convert a Leigh Bowery into someone of (temporary) social status.*

KEVIN KILLIAN is a San Francisco poet, novelist, playwright, and critic. With Dodie Bellamy, he edits the literary/arts zine *Mirage #4/Period[ical]*. He has written for such journals as *Artforum*, *Nest*, *Artweek*, *Bookforum*, and *NYFA Quarterly*. Killian's most recent books are *I Cry Like a Baby* and *Island of Lost Souls*.

PLATES

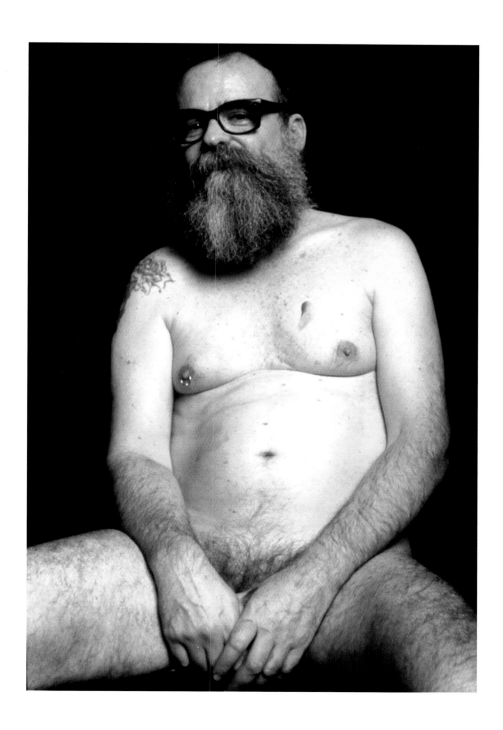

**Bruce
LaBruce**

Naked AA Bronson
2003

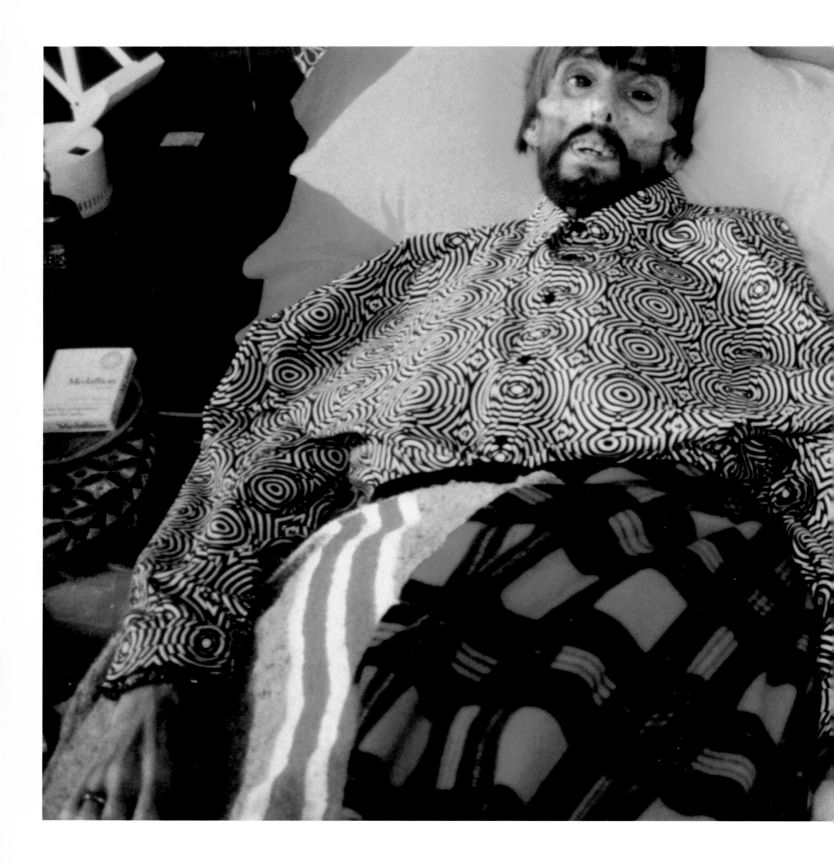

AA
Bronson

Felix Partz, June 5, 1994
1994/1999

Felix, June 5, 1994

**Richard
Kern**

Lucy's Bathing Suit
1998

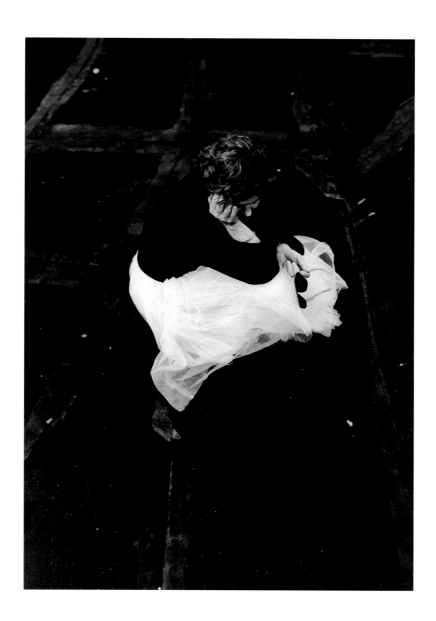

Wolfgang
Tillmans

Isa with pool of water
1995

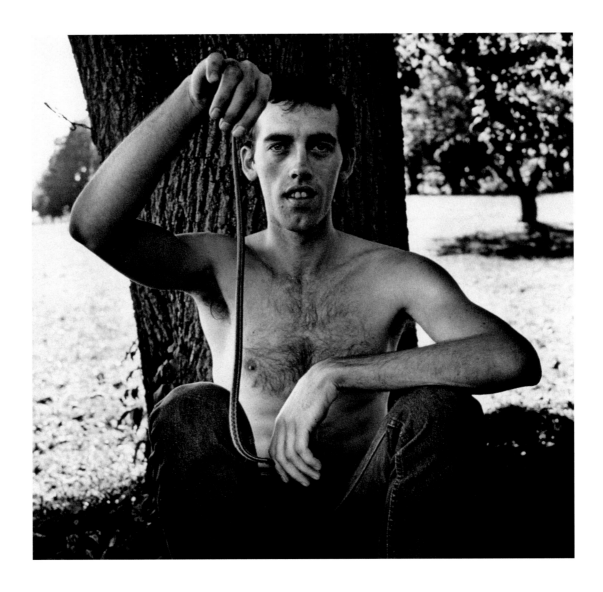

Peter
Hujar

David Wojnarowicz
1981

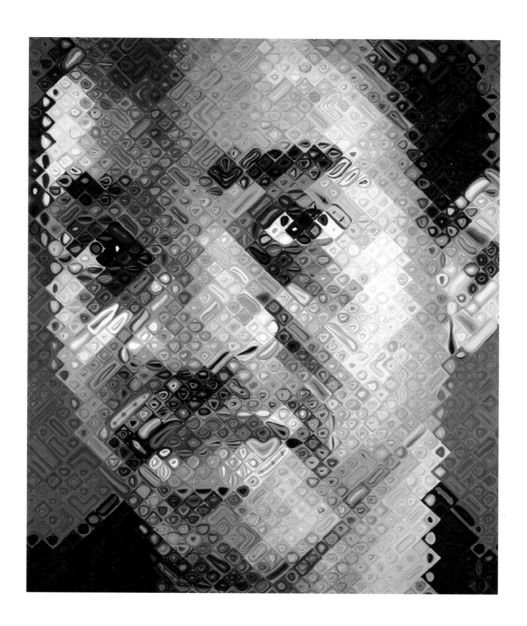

Chuck *Lyle*
Close 2oo3

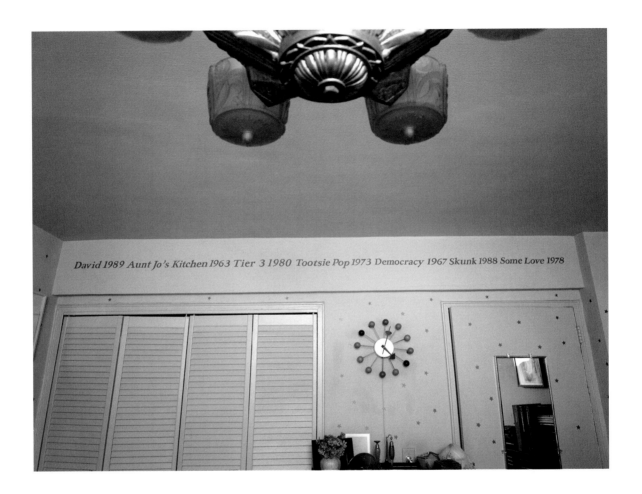

Felix
Gonzalez-Torres

"Untitled" (Portrait of Julie Ault)

1991

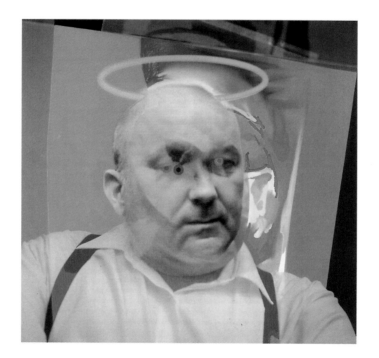

Richard *Portrait of Dieter Roth*
Hamilton 1998

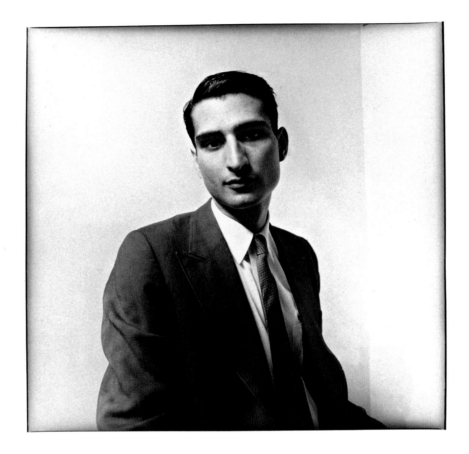

David
Armstrong

Christopher Wool at Elizabeth Street, NYC
1980

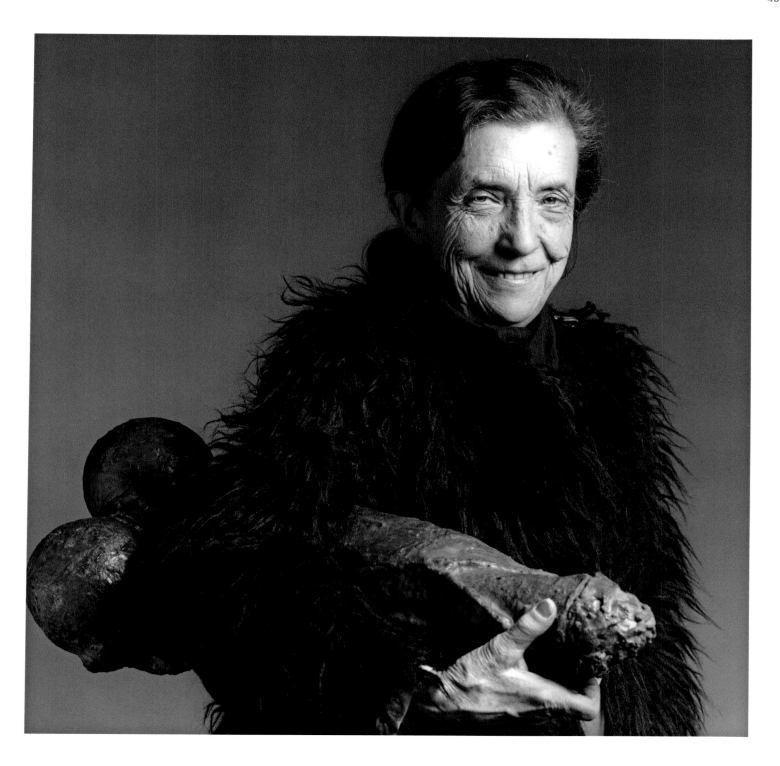

Robert
Mapplethorpe

Louise Bourgeois
1982

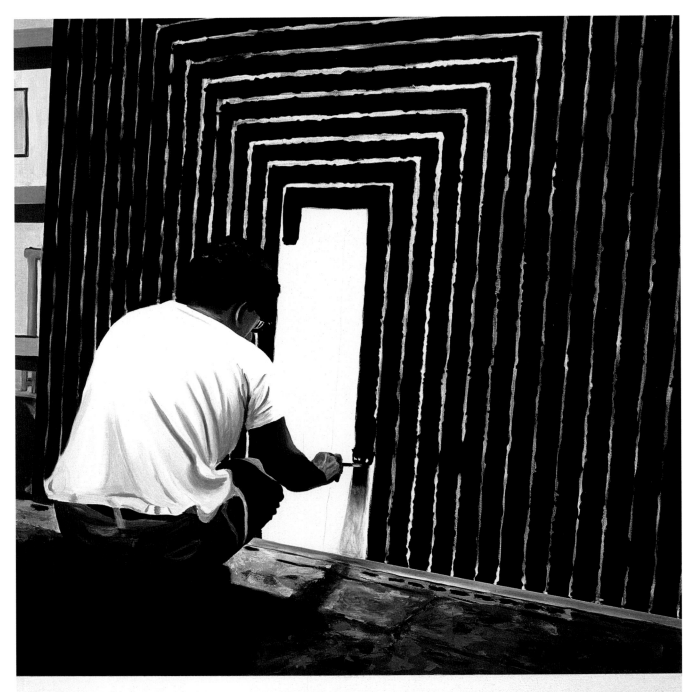

3.4 Hollis Frampton, *Frank Stella,* 1959. Here Stella crouches to work on the same black painting in his West Broadway studio.

Matthew Antezzo

Machine in the Studio: Constructing the Post-War American Artist,
ISBN 0226406490, 1999

Matthew *Nach-Bild*
Antezzo 2001

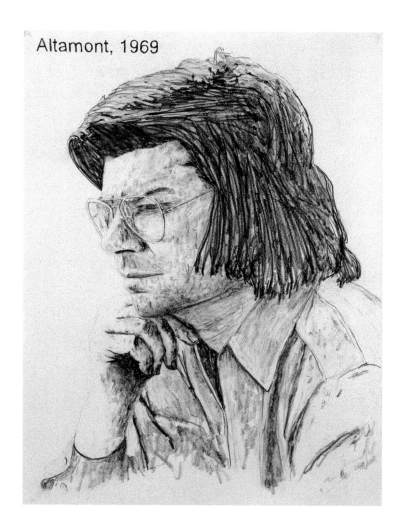

Altamont, 1969

Sam *Altamont, 1969*
Durant 1998

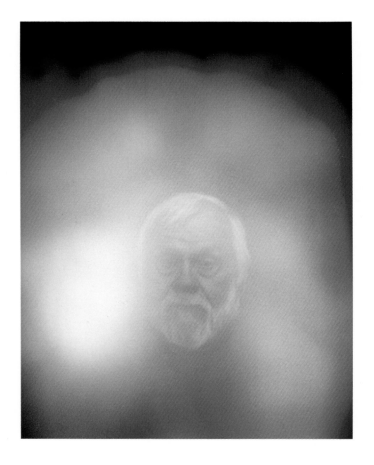

Anne
Collier

Untitled Aura Photograph (John Baldessari)
2003

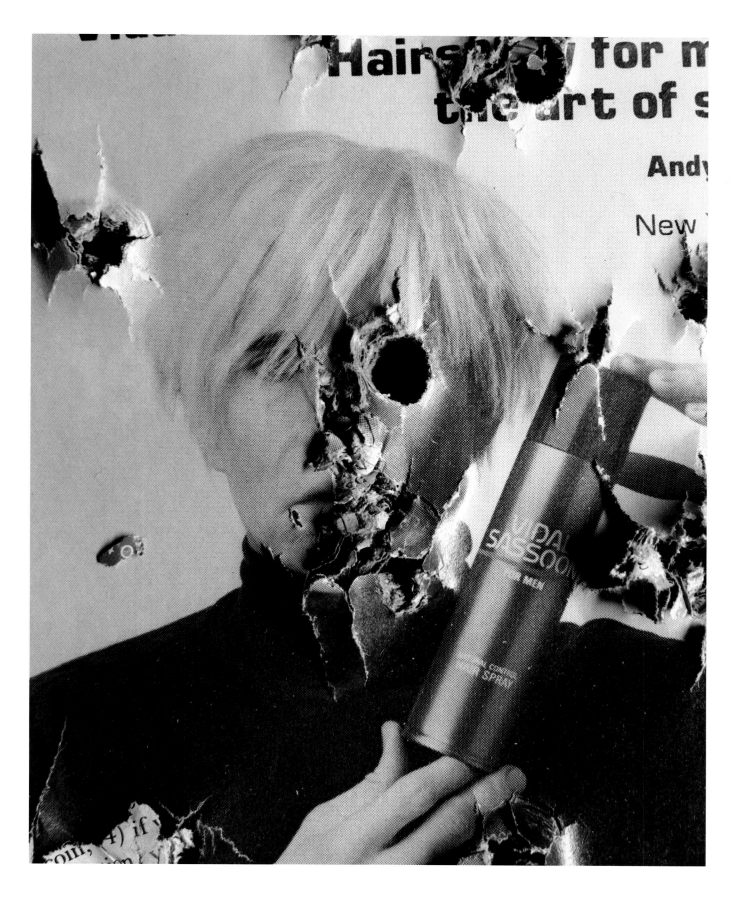

Richard Misrach *Playboy #38 [Andy Warhol]*
 1990

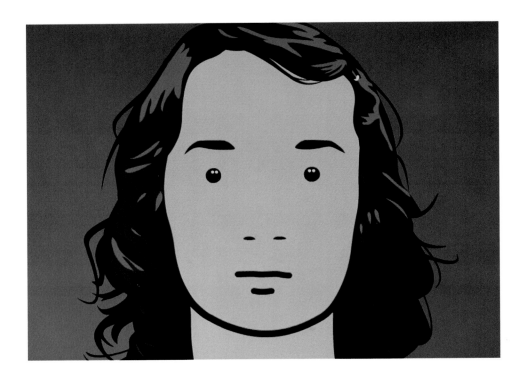

**Julian
Opie**

This is Fiona (still)
2000

Dave Muller

Study for *From Half-Tone Ad (Large)*
1998/2003
(catalog only)

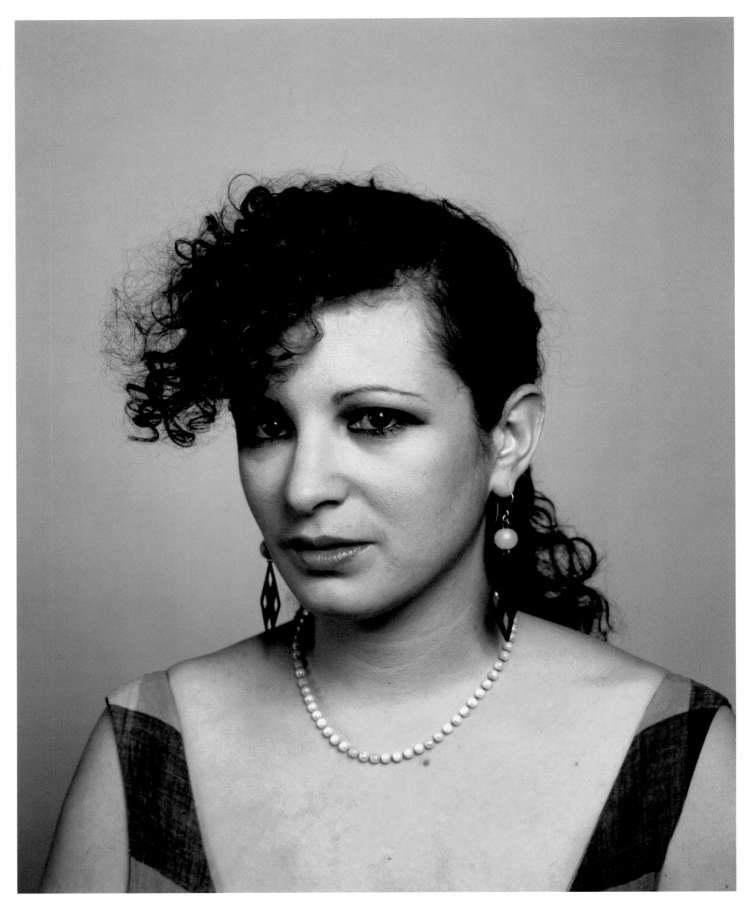

Neil
Winokur

Nan Goldin
1980

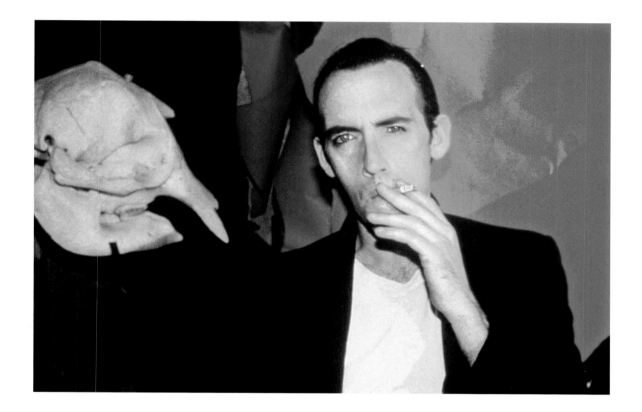

Nan
Goldin

David Wojnarowicz at Home, NYC
1990

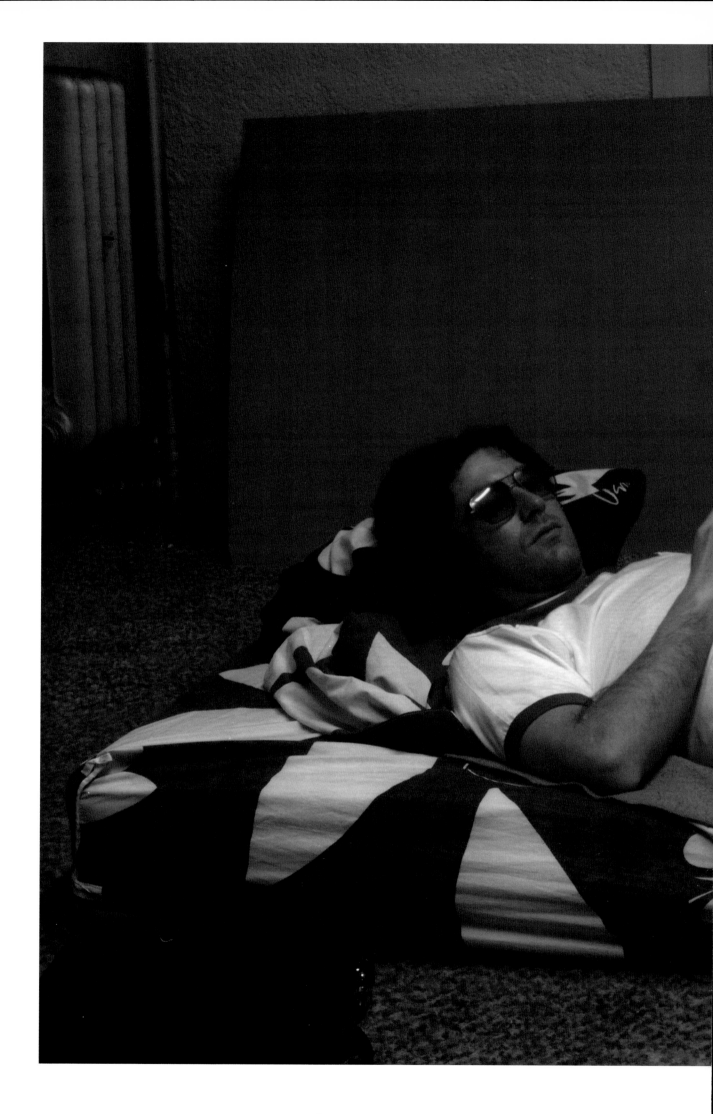

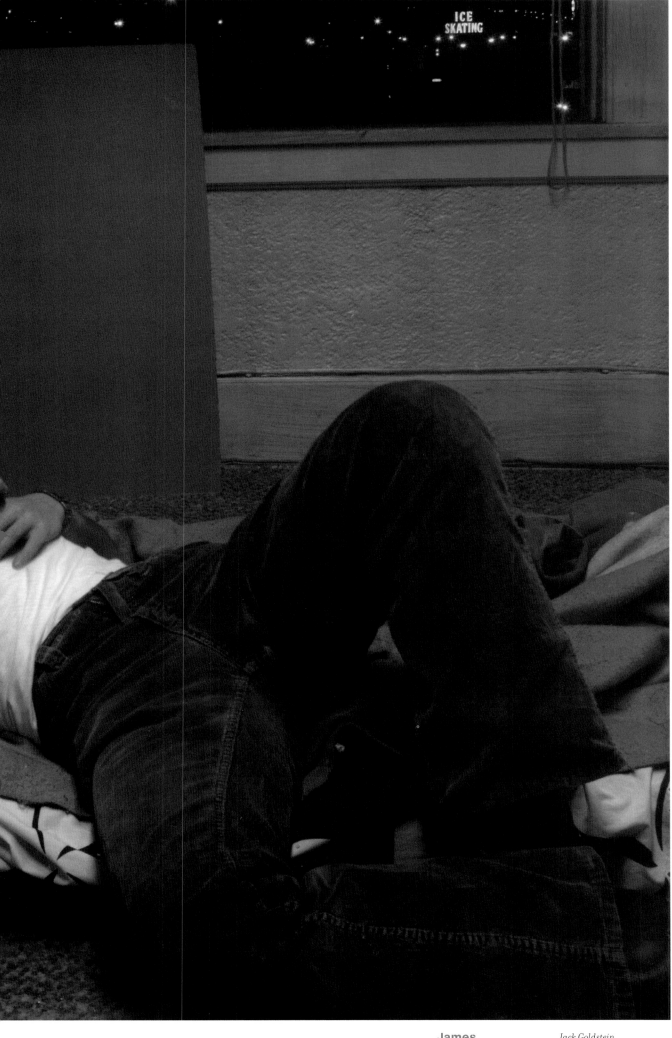

**James
Welling**

Jack Goldstein
1977

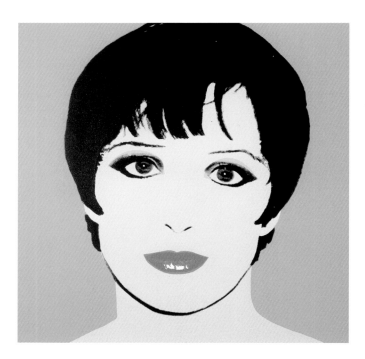

Deborah Kass

Cindy Sherman
1994

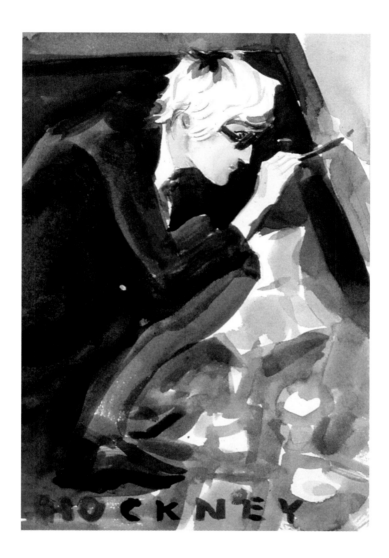

Elizabeth
Peyton

David Hockney
1997

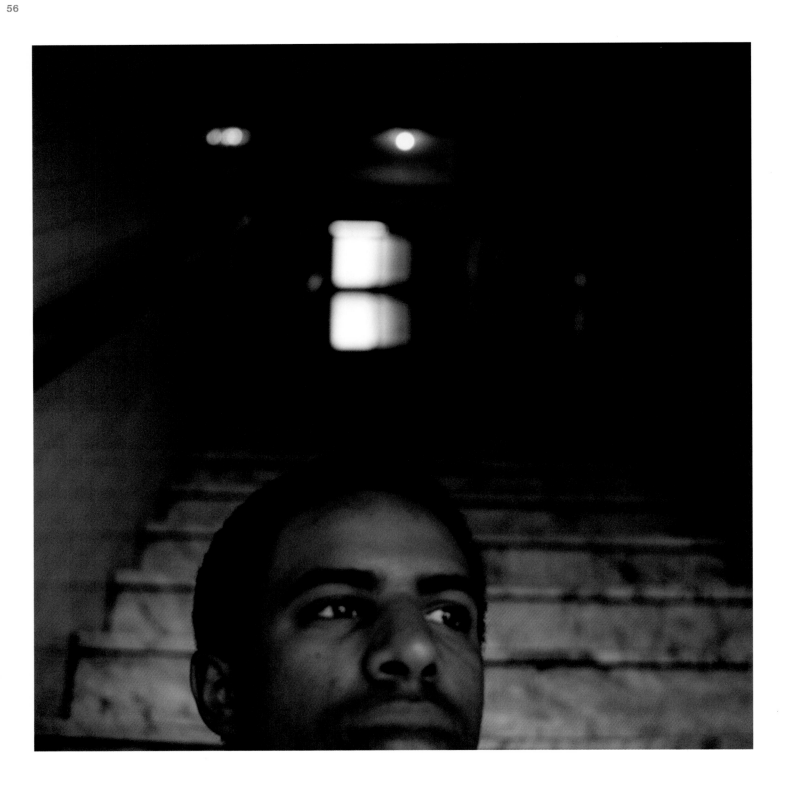

Roy
Arden

Stan Douglas (#2)
1981–5

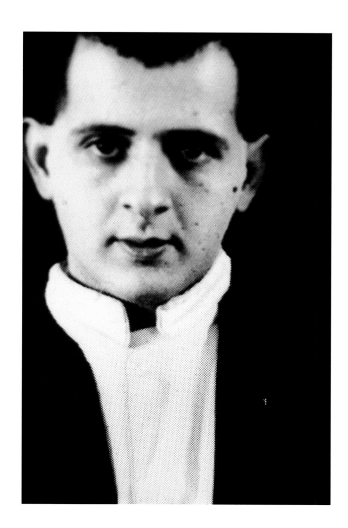

Richard
Prince

Untitled (Meyer Vaisman)
1985

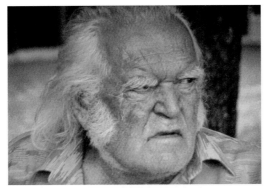

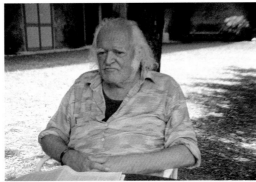

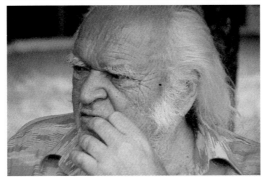

Tacita
Dean

Mario Merz (film stills)
2002

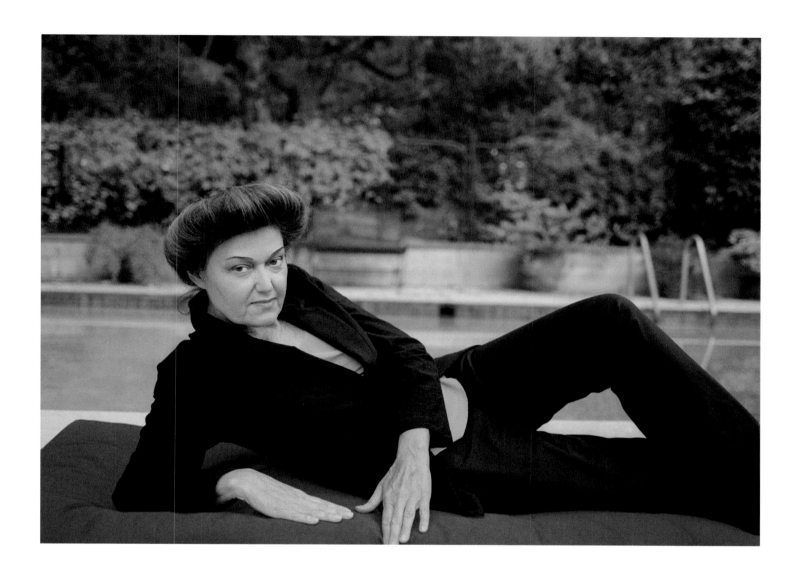

**Heather
Cantrell**

Singing Sirens (Mary Kelly)
2002

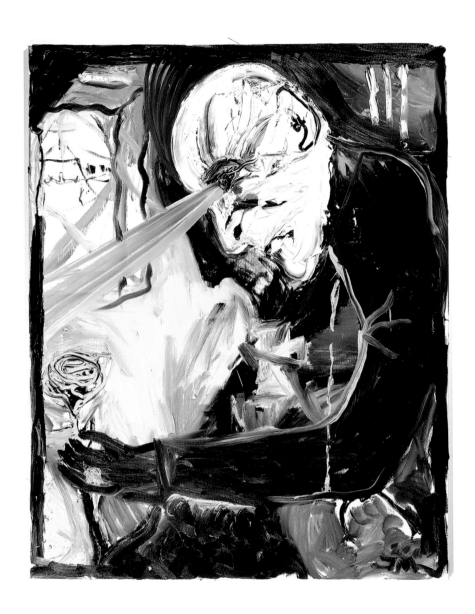

**Jonathan
Meese**

Balthys I
2001

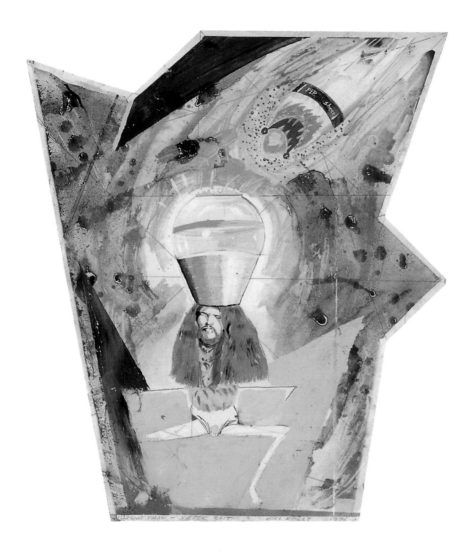

Mike Kelley

Portrait of Jim Shaw
1976

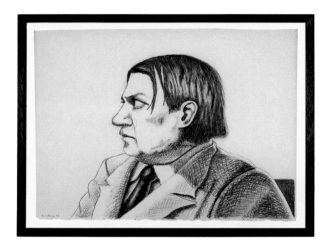

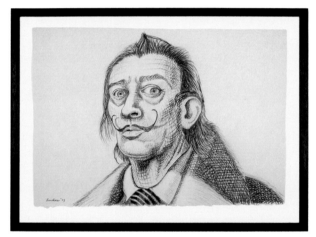

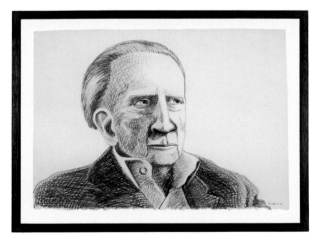

**Sean
Landers**

Picasso
Dali
Duchamp
all 2003

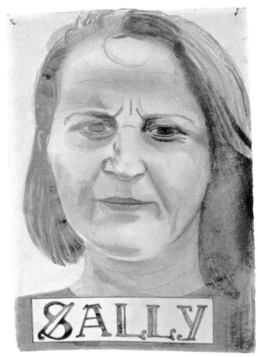

Paul
Noble

Drawings of people who own books (Colin)
Drawings of people who own books (Sally)
both 1993–5

**Sigmar
Polke**

Untitled (Gilbert & George in Willich)
1974

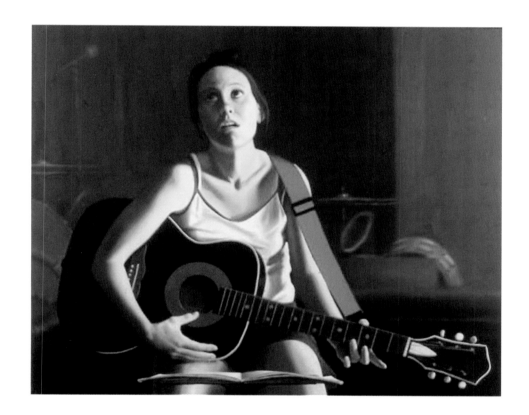

Edgar *Untitled*
Bryan 2001

ARTIST
BIOGRAPHIES

Matthew Antezzo was born in 1962 in Connecticut and lives and works in New York. Antezzo has had solo exhibitions at venues including Sprüth Magers Projekte, Munich (2003); Maccarone, New York (2003); and the Forum for Contemporary Art, St. Louis (1999). His work has also been presented in group exhibitions including *Influence, Anxiety, and Gratitude*, MIT List Visual Arts Center, Cambridge, Massachusetts (2002), and *Nach-Bild*, Kunsthalle Basel, Switzerland (1999).

Roy Arden was born in 1957 in Vancouver, British Columbia, where he continues to live and work. Arden has had solo shows at venues including Vox, Montreal (2002, traveling); Gilles Peyroulet & Cie, Paris (2001); and Patrick Painter Inc., Santa Monica, California (2000). His work has been included in group exhibitions such as *Shopping: Art and Consumer Culture*, Schirn Kunsthalle, Frankfurt (2002, traveling); *Processo Documentals*, Museu d'Art Contemporani, Barcelona (2001); and *Deep Distance*, Kunsthalle Basel (2000).

David Armstrong was born in 1954 in Arlington, Massachusetts, and currently lives and works in New York. Armstrong has had solo exhibitions at venues including Matthew Marks Gallery, New York (2002, 1997, 1995), and Galerie M+R Fricke, Berlin (2001). His work has been presented in group exhibitions such as *Visions from America: Photographs from the Whitney Museum of American Art, 1940–2001*, Whitney Museum of American Art, New York (2002), and *Photography in Boston: 1955–1985*, DeCordova Museum and Sculpture Park, Lincoln, Massachusetts (2000).

AA Bronson was born in 1946 in Vancouver, British Columbia, and lives and works in Toronto and New York. Bronson was part of the artists' group General Idea from 1969 until the deaths of his two partners in 1994. Since that time he has had solo exhibitions at venues including The Power Plant, Toronto (2003–4); Ikon Gallery, Birmingham, England (2003); and the Museum of Contemporary Art, Chicago (2001). His work has also been presented in group exhibitions such as the Whitney Biennial, Whitney Museum of American Art, New York (2002); the Montreal Biennale, CIAC, Montreal (2000); and *Dream City*, Museum Villa Stuck, Munich (1999).

Edgar Bryan was born in 1970 in Birmingham, Alabama, and lives and works in Los Angeles. Bryan has had solo exhibitions at Transmission Gallery, Glasgow (2003), and China Art Objects, Los Angeles (2002). His work has been included in group shows such as *Intimates*, Angles Gallery, Santa Monica (2003); *Hello, My Name Is...*, Carnegie Museum of Art, Pittsburgh (2002); and *Snapshot, New Art from L.A.*, UCLA Hammer Museum, Los Angeles (2001).

Heather Cantrell was born in 1972 in Louisville, Kentucky, and lives and works in Los Angeles. Cantrell has had solo exhibitions at 4-F Gallery, Los Angeles, and Sandroni Rey Gallery, Venice, California (both 2003). Her work has been presented in group shows including *Angst*, RARE Gallery, New York (2003); *Girl on Girl*, Miller Durazo Gallery, Los Angeles (2002); and *The Worst of Gordon Pym continued*, Printed Matter, New York (2001).

Chuck Close was born in 1940 in Monroe, Washington, and currently lives and works in New York. Close has been the subject of a major retrospective organized by the Museum of Modern Art, New York (1998–9, traveling), and has had recent solo shows at White Cube 2, London (2003), and Pace/MacGill Gallery, New York (2002). His work has also been presented in group exhibitions such as the Kwangju Biennial, Korea (2000); *The Nude in Contemporary Art*, Aldrich Contemporary Art Museum, Ridgefield, Connecticut (1999); and *Ghost in the Shell: Photography and the Human Soul, 1850–2000*, Los Angeles County Museum of Art (1997).

Anne Collier was born in 1970 in Los Angeles, California, and lives and works in Oakland, California. Recent solo exhibitions of Collier's work have been presented at Jack Hanley Gallery, San Francisco (2004), and MARC FOXX, Los Angeles (2002, 2001). Her work has also been included in group exhibitions such as *A Show That Will Show That a Show Is Not Only a Show*, The Project, Los Angeles (2002); *Bay Area Now III*, Yerba Buena Center for the Arts, San Francisco (2002); and *I Want More*, Temple Bar Gallery, Dublin, Ireland (2001).

Tacita Dean was born in 1965 in Canterbury, England, and currently lives and works in London and Berlin. Dean has had solo exhibitions at venues including ARC, Musée d'art moderne de la ville de Paris (2003); Museu Serralves, Porto, Portugal (2002); and Tate Britain, London (2001). Her work has also been presented in group exhibitions such as *Liquid Sea*, Museum of Contemporary Art, Sydney (2003); *The Moderns*, Castello di Rivoli, Museo d'arte contemporanea, Turin (2003); and *Extreme Connoisseurship*, Fogg Art Museum, Harvard University, Cambridge, Massachusetts (2002).

Sam Durant was born in 1961 in Seattle, Washington, and lives and works in Los Angeles. Recent solo exhibitions of his work have been presented at the Kunstverein Düsseldorf, Germany (2003); Museum of Contemporary Art, Los Angeles (2002–3); and the Wadsworth Atheneum Museum of Art, Hartford, Connecticut (2002). Durant's work will also be presented in the Whitney Biennial, Whitney Museum of American Art, New York (2004), and *Playlist*, Palais de Tokyo, Paris (2004), and was included in the Venice Biennale (2003).

Nan Goldin was born in 1953 in Washington, D.C., and lives and works in Paris and New York. Recent solo exhibitions of Goldin's work have been presented at the Musée nationale d'art moderne, Centre Georges Pompidou, Paris (traveling, 2001–2); Contemporary Art Museum, Houston (1999); and the National Gallery of Iceland, Reykjavik (1999). Her work has also been presented in group exhibitions including *Settings and Players: Theatrical Ambiguity in American Photography*, White Cube, London (2001); the 46th Biennial Exhibition, Corcoran Museum of Art, Washington, D.C. (2000); and *Identity Crisis: Self-Portraiture at the End of the Century*, Milwaukee Art Museum, Milwaukee (1997).

Felix Gonzalez-Torres was born in Güaimaro, Cuba, in 1957, and died in Miami, Florida, in 1996. A retrospective exhibition of Gonzalez-Torres's work was organized by the Solomon R. Guggenheim Museum, New York (1995, traveling). Other solo exhibitions have been presented at venues including the Serpentine Gallery, London (2000), and the Museum of Contemporary Art, Los Angeles (1994). His work has also been included in group shows such as the 10th Biennale of Sydney, Art Gallery of New South Wales (1996); *Portraits, Plots, and Places: The Permanent Collection Revisited*, Walker Art Center, Minneapolis (1992); and *Art about AIDS*, Freedman Gallery, Albright College Center for the Arts, Reading, Pennsylvania (1989).

Richard Hamilton was born in 1922 in London, England, and lives and works in Oxfordshire. Hamilton has shown most recently at Gagosian, London (2003), and has been the subject of retrospective exhibitions organized by Museum Ludwig, Cologne (2003–4), and the Tate Gallery, London (1992). His work has also been included in major group exhibitions such as *Pop Art*, Royal Academy of Arts, London (1991, traveling), and *The Independent Group*, Institute of Contemporary Arts, London (1990, traveling).

Peter Hujar was born in Trenton, New Jersey, in 1934 and died in 1987 in New York. A major Hujar retrospective was organized by the Stedelijk Museum, Amsterdam (1994), and he was the subject of solo exhibitions at Matthew Marks Gallery, New York (2000), and Grey Art Gallery and Study Center, New York University, New York (1990). His work was presented in group shows including *Self and Shadow*, Aperture Foundation (Burden Gallery), New York (1989); *Vollbild* [The Full Picture], Die Neue Gesellschaft für Bildende Künste, Berlin (1988); and *Nude Stripped Bare*, List Visual Arts Center, MIT, Cambridge, Massachusetts (1985).

Deborah Kass was born in 1952 in San Antonio, Texas, and lives and works in Brooklyn, New York. Recent solo exhibitions of Kass's work have been shown at the Weatherspoon Art Gallery, University of North Carolina at Greensboro (2001, traveling); the Kemper Museum of Contemporary Art and Design, Kansas City (1996, traveling); and Barbara Krakow Gallery, Boston (1994). Her work has been included in group exhibitions such as *Crimes and Misdemeanors: Politics in U.S. Art of the 1980s*, Contemporary Arts Center, Cincinnati (2003); *In Your Face*, The Warhol Museum, Pittsburgh (1998); and *NowHere: Incandescent*, Louisiana Museum of Art, Humlebaek, Denmark (1996).

Mike Kelley was born in 1954 in Detroit, Michigan, and lives and works in Los Angeles. Recent solo exhibitions of Kelley's work have been presented at the Museu d'Art Contemporani, Barcelona (2000); Kunstverein Braunschweig (1999); and the Whitney Museum of American Art, New York (1993). His work has been included in group exhibitions such as *Capp Street Project: 20th Anniversary Exhibition*, CCA Wattis Institute for Contemporary Arts, San Francisco (2003); Bienal de Valencia (2001); and Documenta X, Kassel, Germany (1997).

Richard Kern was born in 1954 in Roanoke Rapids, North Carolina, and lives and works in New York. Recent solo shows of Kern's work have been presented at Feature Inc., New York (2001); Galerie Patrick Seguin, Paris (2000); and Reali, Brescia, Italy (1998). His work has also been included in group shows such as *Full Serve*, Rove, New York (2000); *Salome: Images of Women in Contemporary Art*, Castle Gallery, College of New Rochelle, New Rochelle, New York (1999); and *Disidentico*, Palazzo Brancifonte, Palermo, Italy (1998).

Bruce LaBruce was born in 1964 in Southampton, Ontario, and currently lives and works in Los Angeles. A filmmaker and photographer, LaBruce has had solo shows at peres projects, Los Angeles (2004); John Connelly Presents, New York (2003); and MC MAGMA, Milan (2001). His work has also been presented in group shows including *Hovering* at peres projects, Los Angeles (2003), and *Corporate Profits vs. Labor Costs* at D'Amelio Terras, New York (2002).

Sean Landers was born in 1962 in Palmer, Massachusetts, and lives and works in New York. Recent solo exhibitions of Landers's work have been presented at Andrea Rosen Gallery, New York (2004, 2001, 1999, 1997); Greengrassi, London (2003); and Galerie Jennifer Flay, Paris (2001). His work has also been shown in group exhibitions including *Face/Off: A Portrait of the Artist*, Kettle's Yard, Cambridge, England (touring, 2002–3); *To Whom It May Concern*, CCA Wattis Institute for Contemporary Arts, San Francisco (2002); and *Tele(visions)*, Kunsthalle Vienna, Austria (2001).

Robert Mapplethorpe was born in 1946 on Long Island, New York, and died in 1989 in New York. Mapplethorpe was the subject of solo shows organized by Louisiana Museum of Modern Art, Humlebaek, Denmark (1992, traveling); the Whitney Museum of American Art, New York (1988); and the Centre Georges Pompidou, Paris (1983). His work was included in group exhibitions such as *Moving Pictures*, Solomon R. Guggenheim Museum, New York (2002); *The Warhol Look/Glamour Style Fashion*, Whitney Museum of American Art, New York (1997); and the Whitney Biennial, Whitney Museum of American Art, New York (1981).

Jonathan Meese was born in 1971 in Tokyo, Japan, and lives and works in Berlin, Germany. Recent solo exhibitions of Meese's work have been shown at Leo Koenig, New York (2004); Kestner-Gesellschaft, Hanover, Germany (2002); and Kunst-Werke, Berlin (2000). His work has also been presented in group shows including *Berlin-Moscow/Moscow-Berlin 1950–2000*, Gropius Bau, Berlin (2003); *Grotesk!*, Schirn Kunsthalle, Frankfurt (2003, traveling); and *Generation Z*, P.S.1, Long Island City, New York (1999).

Richard Misrach was born in 1949 in Los Angeles, California, and lives and works in Berkeley, California. Misrach's recent solo shows have been presented at Fraenkel Gallery, San Francisco (2004, 2002); Berkeley Art Museum, Berkeley, California (2002); and the High Museum of Art, Atlanta (2000). His work has been included in group exhibitions such as *The Gray Area: Uncertain Images—Bay Area Photography 1970s to Now*, CCA Wattis Institute for Contemporary Arts, San Francisco (2003); *Visions from America: Photographs from the Whitney Museum of American Art, 1940–2001*, New York (2002); and *Scene of the Crime*, UCLA Hammer Museum, Los Angeles (1997).

Dave Muller was born in 1964 in San Francisco, California, and lives and works in Los Angeles. Recent solo exhibitions of his work have been presented at the San Francisco Museum of Modern Art, San Francisco (2004); Center for Curatorial Studies Museum, Bard College, Annandale-on-Hudson, New York (2002, traveling); and Saint Louis Art Museum, Saint Louis (2001). Muller's work has been included in group shows such as the Whitney Biennial, Whitney Museum of American Art, New York (2004); *Playlist*, Palais de Tokyo, Paris (2004); and the Lyons Biennale of Contemporary Art, Lyons (2003).

Paul Noble was born in 1963 in Northumberland, England, and lives and works in London, England. Recent solo shows of Noble's work have been presented at the Whitechapel Art Gallery, London (2004); Albright Knox Gallery, Buffalo, New York (2003); and Musée d'art moderne et contemporain, Geneva (2001). His work has been included in group exhibitions such as the Eighth International Istanbul Biennial (2003); *Living Inside the Grid*, New Museum, New York (2003); and *Drawing Now: Eight Propositions*, Museum of Modern Art, New York (2002).

Julian Opie was born in 1958 in London, England, where he continues to live and work. Recent solo exhibitions of his work have been presented at the Neues Museum, Nuremberg (2003); Ikon Gallery, Birmingham, England (2001); and the Stadtgalerie am Lehnbachhaus, Munich (1999). His work has been shown at the Bienal de Valencia (2003) and in group exhibitions including *Babel 2002*, National Museum of Contemporary Art, Seoul (2002), and New British Art 2000: *Intelligence*, Tate Britain, London (2000).

Elizabeth Peyton was born in 1965 in Danbury, Connecticut, and lives and works in New York. Recent solo exhibitions of Peyton's work have been presented at the Salzburger Kunstverein, Salzburg (2002); the Deichtorhallen, Hamburg (2001); and the Museum of Contemporary Art, Castello di Rivoli, Turin (1999). Her work has been included in group shows such as *The Fourth Sex: Adolescent Extremes*, Pitti Imagine Discovery, Milan (2003); *Drawing Now: Eight Propositions*, Museum of Modern Art, New York (2002); and *Greater New York*, P.S.1, Long Island City, New York (2000).

Sigmar Polke was born in 1941 in Oels, Germany, and lives and works in Cologne. Polke has been the subject of a major exhibition at Tate Modern, London (2003–4), and has had recent solo shows at the Dallas Museum of Art, Dallas (2002, traveling), and the Louisiana Museum, Humlebaek, Denmark (2001). His work was included in the Venice Biennale (1999) and in group shows such as the Carnegie International, Pittsburgh (1995), and *Magiciens de la Terre*, Musée nationale d'art moderne, Centre Georges Pompidou, Paris (1989). He was awarded the Golden Lion at the Venice Biennale (1986).

Richard Prince was born in 1949 in the Panama Canal Zone and lives and works in upstate New York. Prince has been the subject of solo shows at the Museum für Gegenwartskunst, Basel, and Kunsthalle Zurich (2001, traveling); the Museum für Angewandte Kunst, Vienna (2000); and the Whitney Museum of American Art, New York (1992). His work has also been included in group exhibitions such as the Venice Biennale (2003); *Settings and Players: Theatrical Ambiguity in American Photography*, White Cube, London (2001); and the Whitney Biennial, Whitney Museum of American Art, New York (1997).

David Robbins was born in 1957 in Whitefish Bay, Wisconsin, and lives and works in Milwaukee. Robbins's recent solo shows have been presented at Feature Inc., New York (2001, 1998); Cubitt, London (2001); and the Institute of Visual Art, University of Wisconsin-Milwaukee (2000). His work has been included in group shows such as the Liverpool Biennial, Liverpool (1999), and the German Reunification Public Sculpture Competition, Galerie Christian Nagel, Cologne (1991).

Wolfgang Tillmans was born in 1968 in Remscheid, Germany, and lives and works in London, England. Tillmans was the subject of a major retrospective at Tate Britain, London (2003), and won the Tate Turner Prize in 2001. His work has been presented in group exhibitions including *Moving Pictures*, Solomon R. Guggenheim Museum, New York (2002–3); *Uniform. Order and Disorder*, P.S.1, Long Island City, New York (2001); and *Protest and Survive*, Whitechapel Art Gallery, London (2000).

James Welling was born in 1951 in Hartford, Connecticut, and lives and works in Los Angeles. Welling's recent solo exhibitions have been shown at the Museum of Contemporary Photography, Columbia College, Chicago (2003); Palais de Beaux-Arts, Brussels (2002); and the Wexner Center for the Arts, Columbus, Ohio (2000, traveling). His work has been presented in group exhibitions including at the Sprengel Museum, Hanover, Germany (1999); Documenta IX, Kassel, Germany (1992); and *The Indomitable Spirit*, International Center of Photography Midtown, New York (1990).

Neil Winokur was born in 1945 in New York, where he continues to live and work. Winokur's solo exhibitions have been presented at Janet Borden Inc., New York (1997, 1996); Galerie du Jour Agnès B., Paris (1995); and Denver Art Museum, Denver (1993). His work has also been included in group exhibitions such as *Photographing Undomesticated Interiors*, Nixon Gallery, Brown Fine Arts Center, Smith College, Northampton, Massachusetts (2004); *Future Present: Photographs of Children from the Reader's Digest Collection*, Aldrich Contemporary Art Museum, Ridgefield, Connecticut (1999); and *Babies*, Bravin Post Lee, New York (1996).

WORKS IN THE
EXHIBITION

Matthew Antezzo
Nach-Bild, 2001 (P. 44)
Oil on linen
72.24" x 58.66"
Iann & Stolz

Roy Arden
Stan Douglas (#1), 1981–5 (P. 72)
Cibachrome print
8" x 8"
Collection of the artist; courtesy Elizabeth Dee
Gallery, New York

Stan Douglas (#2), 1981–5 (P. 56)
Cibachrome print
8" x 8"
Collection of the artist; courtesy Elizabeth Dee
Gallery, New York

David Armstrong
Christopher Wool at Elizabeth Street, NYC, 1980
(P. 42)
Gelatin silver print
24" x 20"
Edition of 5
Courtesy the artist and Matthew Marks Gallery,
New York

AA Bronson
Felix Partz, June 5, 1994, 1994/1999 (PP. 34–35)
Lacquer on vinyl
84" x 168"
Courtesy John Connelly Presents, New York

Edgar Bryan
Untitled, 2001 (P. 65)
Oil on canvas
34" x 40"
Collection of Dean Valentine and Amy Adelson, Los
Angeles

Heather Cantrell
Singing Sirens (Mary Kelly), 2002 (COVER, P. 59)
Chromogenic print
20" x 24"
Courtesy the artist

Chuck Close
Lyle, 2003 (P. 39)
Silkscreen
65 1/4" x 53 7/8"
Courtesy Pace Editions

Anne Collier
Untitled Aura Photograph (Mike Kelley), 2003
Polaroid photograph
4 1/4" x 3 3/8"

Untitled Aura Photograph (Cerith Wyn Evans), 2003
Polaroid photograph
4 1/4" x 3 3/8"

Untitled Aura Photograph (Frances Stark), 2003
Polaroid photograph
4 1/4" x 3 3/8"

Untitled Aura Photograph (Vincent Fecteau), 2003
Polaroid photograph
4 1/4" x 3 3/8"

Untitled Aura Photograph (John Baldessari), 2003
(P. 46)
Polaroid photograph
4 1/4" x 3 3/8"

All courtesy the artist and MARC FOXX, Los Angeles

Tacita Dean
Mario Merz, 2002 (P. 58)
16 mm film projection, color, optical sound
8 1/2 minutes
Courtesy Frith Street Gallery, London, and
Marian Goodman Gallery, New York
[CCA Wattis Institute, San Francisco, only]

Sam Durant
Altamont, 1969, 1998 (P. 45)
Pencil on paper
30" x 24"
Collection of Ann Kneedler, Los Angeles;
courtesy Blum & Poe, Los Angeles

Nan Goldin
David Wojnarowicz at Home, NYC, 1990 (P. 51)
Cibachrome print
30" x 40"
Edition of 25
Courtesy the artist and Matthew Marks Gallery,
New York

Felix Gonzalez-Torres
"Untitled" (Portrait of Julie Ault), 1991 (P. 40)
Paint on wall
Dimensions variable
Collection of Julie Ault

Richard Hamilton
Portrait of Dieter Roth, 1998 (P. 41)
Iris print
Paper: 24 3/4" x 22 3/4"
Image: 15 3/4" x 15 3/4"
Edition of 50
Courtesy the artist and Alan Cristea Gallery,
London

Peter Hujar
Paul Thek, 1975
Vintage silver print
15 3/4" x 20"
Courtesy the estate of Peter Hujar and Matthew
Marks Gallery, New York

David Wojnarowicz, 1981 (P. 38)
Vintage silver print
15 3/4" x 19 13/16"
Courtesy the estate of Peter Hujar and Matthew
Marks Gallery, New York

Deborah Kass
Cindy Sherman, 1994 (P. 54)
Silkscreen ink and acrylic on canvas
Two parts: 40" x 40" each, 40" x 80" overall
Courtesy the artist

Elizabeth Murray, 1994
Silkscreen ink and acrylic on canvas
Two parts: 40" x 40" each, 40" x 80" overall
Courtesy the artist and Elizabeth Murray

Mike Kelley
Portrait of Jim Shaw, 1976 (P. 61)
Mixed media on paper
24" x 20"
Collection of Jim Shaw, Los Angeles

Richard Kern
Lucy in the Bathroom (Paris), 1997
Color photograph
14" x 11"
Courtesy the artist

Lucy's Zits, 1997
Color photograph
14" x 11"
Courtesy the artist

Lucy's Bathing Suit, 1998 (P. 36)
Color photograph
14" x 11"
Courtesy the artist

Bruce LaBruce
Naked AA Bronson, 2003 (P. 33)
Chromogenic print on aluminum
40" x 26 1/4"
Edition of 3 plus 1 A.P.
Courtesy the artist and peres projects, Los Angeles

Sean Landers
Beckmann, 2003
Pencil on paper
14" x 11"
Private collection; courtesy Greengrassi, London

Braque, 2003
Pencil on paper
14" x 11"
Private collection; courtesy Greengrassi, London

Dali, 2003 (P. 62)
Pencil on paper
11" x 14"
Private collection; courtesy Greengrassi, London

De Chirico, 2003
Pencil on paper
14" x 11"
Private collection; courtesy Greengrassi, London

Duchamp, 2003 (P. 62)
Pencil on paper
11" x 14"
Private collection; courtesy Greengrassi, London

Ernst, 2003
Pencil on paper
11" x 14"
Private collection; courtesy Greengrassi, London

Magritte, 2003
Pencil on paper
14" x 11"
Private collection; courtesy Greengrassi, London

Picabia, 2003
Pencil on paper
11" x 14"
Private collection; courtesy Greengrassi, London

Picasso, 2003 (P. 62)
Pencil on paper
11" x 14"
Private collection; courtesy Greengrassi, London

Robert Mapplethorpe
Christopher Knowles, 1977
Gelatin silver print
20" x 20"
Courtesy Robert Mapplethorpe Foundation,
New York

Louise Bourgeois, 1982 (P. 43)
Gelatin silver print
20" x 16"
Courtesy Robert Mapplethorpe Foundation,
New York

Jonathan Meese
Balthys I, 2001 (P. 60)
Oil on canvas
63" x 47 1/4" x 3/4"
Collection of Susan and Michael Hort, New York

Richard Misrach
Playboy #38 [Andy Warhol], 1990 (P. 47)
Ektacolor Plus print
50" x 40"
A.P.
Courtesy the artist and Fraenkel Gallery,
San Francisco

Dave Muller
From Half-Tone Ad (Large), 1998/2003 (P. 49)
Acrylic on paper
40" x 32"
Courtesy the artist

Paul Noble
Drawings of people who own books (Colin), 1993–5
(P. 63)
Pencil on paper
11 5/12" x 8 1/2"
Courtesy the artist and Maureen Paley Interim
Art, London

Drawings of people who own books (Patrick), 1993–5
Pencil on paper
11 5/12" x 8 1/2"
Courtesy the artist and Maureen Paley Interim
Art, London

Drawings of people who own books (Sally), 1993–5
(P. 63)
Pencil on paper
11 5/12" x 8 1/2"
Courtesy the artist and Maureen Paley Interim
Art, London

Julian Opie
This is Fiona, 2000 (P. 48)
Computer film on CD-ROM
Continuous loop
Courtesy the artist and Lisson Gallery, London

Elizabeth Peyton
David Hockney, 1997 (P. 55)
Watercolor on paper
7" x 10 1/2"
Collection of Nancy and Joel Portnoy

Nick, 2003
Seven-color etching with aquatint
Image: 31 3/4" x 24"
Paper: 40 1/2" x 32"
Edition of 30
Courtesy Two Palms Press, New York

Sigmar Polke
Untitled (Gilbert & George in Willich), 1974 (P. 64)
Four gelatin silver prints
9 3/8" x 11 3/4" each
Courtesy Fraenkel Gallery, San Francisco
[CCA Wattis Institute, San Francisco, only]

Richard Prince
Untitled (Meyer Vaisman), 1985 (P. 57)
Ektacolor photograph
24" x 20"
Edition 1 of 2
Courtesy Barbara Gladstone Gallery, New York

David Robbins
Talent, 1986 (PP. 20–21)
Eighteen gelatin silver prints
10" x 8" each, installation dimensions variable
Collection of Michelle Grabner, Chicago

Wolfgang Tillmans
Isa with pool of water, 1995 (P. 37)
C-print installation
Overall dimensions variable
Courtesy the artist and Andrea Rosen Gallery,
New York

James Welling
Jack Goldstein, 1977 (PP. 2–3, 52–53)
Chromogenic print
9 1/2" x 12"
Courtesy the artist and Regen Projects, Los
Angeles

Wolfgang Tillmans, 2000
Gelatin silver print
10" x 8"
Courtesy the artist and Regen Projects, Los
Angeles

Neil Winokur
Andy Warhol, 1982 (P. 12)
Cibachrome print
20" x 16"
Edition 10/25
Courtesy Janet Borden, Inc., New York

Nan Goldin, 1980 (P. 50)
Cibachrome print
20" x 16"
Edition 2/10
Courtesy Janet Borden, Inc., New York

Robert Mapplethorpe, 1982 (P. 1)
Cibachrome print
20" x 16"
Edition 6/10
Courtesy Janet Borden, Inc., New York

All images are courtesy the artist unless otherwise noted.

Matthew Antezzo (P. 44) Courtesy Klosterfelde Gallery, Berlin
David Armstrong (P. 42) Courtesy Matthew Marks Gallery, New York
Chuck Close (P. 39) Courtesy Pace Editions
Tacita Dean (P. 58) Courtesy Frith Street Gallery, London
Sam Durant (P. 45) Courtesy Blum & Poe, Los Angeles
Nan Goldin (P. 51) Courtesy Matthew Marks Gallery, New York
Felix Gonzalez-Torres (P. 40) © The Felix Gonzalez-Torres Foundation. Courtesy Andrea Rosen Gallery, New York. Photo: Peter Muscato
Richard Hamilton (P. 41) Courtesy Alan Cristea Gallery, London
Peter Hujar (P. 38) Courtesy Matthew Marks Gallery, New York
Bruce LaBruce (P. 33) Courtesy peres projects, Los Angeles
Sean Landers (P. 62) Courtesy Greengrassi, London
Robert Mapplethorpe (P. 43) *Louise Bourgeois*, 1982, MAP #925 © Robert Mapplethorpe Foundation. Used with permission.
Jonathan Meese (P. 60) Courtesy Contemporary Fine Arts, Berlin. Photo: Jochen Littkemann, Berlin
Richard Misrach (P. 47) Courtesy Fraenkel Gallery, San Francisco
Paul Noble (P. 63) Courtesy Maureen Paley Interim Art, London
Julian Opie (P. 48) Courtesy Lisson Gallery, London. Photo: Dave Morgan
Elizabeth Peyton (P. 55) Courtesy Gavin Brown's enterprise, New York
Sigmar Polke (P. 64) © Sigmar Polke. Courtesy Fraenkel Gallery, San Francisco
Richard Prince (P. 57) © 1985 Richard Prince. Courtesy Barbara Gladstone Gallery, New York
David Robbins (PP. 20–21) Courtesy Feature, Inc., New York
Wolfgang Tillmans (P. 37) Courtesy Andrea Rosen Gallery, New York
James Welling (PP. 2–3, 52–53) Courtesy Regen Projects, Los Angeles
Neil Winokur (PP. 1, 50) Courtesy Janet Borden, Inc., New York

The publishers have made every effort to contact all copyright holders. If proper acknowledgment has not been made, we ask copyright holders to contact the publishers.

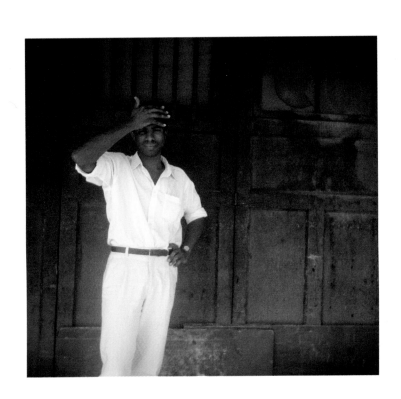